IMAGES
of America

STATEN ISLAND
VOLUME II
A CLOSER LOOK

This book is dedicated to my mother, Margaret Lundrigan, who loved
Staten Island and its history. My mother's trips to Richmondtown and
St. Andrew's started, in me, a lifelong interest in local history. She
believed that books are magical and can open untold worlds to us and
that the only virtues worth pursuing are integrity and kindness. I learned
from her the immense capacity one life can have to affect the world for
good. She lives in the hearts of those who loved her.

—M.L.

IMAGES
of America

STATEN ISLAND
VOLUME II
A CLOSER LOOK

Margaret Lundrigan
and Tova Navarra

ARCADIA

Published by Arcadia Publishing,
an imprint of Tempus Publishing, Inc.
2 Cumberland Street
Charleston, SC 29401

Printed in Great Britain.

Library of Congress Catalog Card Number:

For all general information contact Arcadia Publishing at:
Telephone 843-853-2070
Fax 843-853-0044
E-Mail arcadia@charleston.net

For customer service and orders:
Toll-Free 1-888-313-BOOK

Visit us on the internet at http://www.arcadiaimages.com

CONTENTS

Acknowledgments

If there is truth to the old song "A Good Man is Hard to Find," then it might be said, "A good publisher is damn near impossible." In this volume, the authors would like to make an acknowledgment long overdue. Working with Arcadia publishers in the production of seven books over the past four years has been a joy for both of us. Similar to Scrooge's praise of Mr. Fezziwig in Charles Dickens's well-loved *A Christmas Carol*, Arcadia Publishers may well take its place as a wonderful feast in the field of local publishing. In addition to being great to work with, Arcadia is making an invaluable contribution with its photographic series *Images of America*. The series has taken local history from the obscure back shelves and family trunks in the attic and made it accessible so that we can all enjoy and learn from it. The series not only contributes to knowledge, but recognizes the contributions of the common man and woman who are the cornerstones of all history. We are especially indebted to Alan and Kirsty Sutton for bringing this wonderful form to the United States. It has been a special pleasure to work with everyone at Arcadia, including Amy Sutton, Heather Roy, Sara Long, Pam O'Neil, and Allison Carpenter. We are indebted to Michael Guillory and Mark Berry for their very skillful (and kind) editing. We thank the entire staff for patience and understanding of our idiosyncrasies (such as the tired phrase, "We're waiting for one more really important picture").

As always, we are indebted to our friends at the Staten Island Historical Society: Barnett Shepherd and Judy and Bill McMillen, who, in addition to making their outstanding photographic collection available, provide invaluable research assistance and guidance. And of course, thanks go to Carlotta Defillo, whose expertise and commitment is exceeded only by her good nature. Our friend and colleague Randall Gabrielan has yet again provided marvelous assistance by not only sharing his own collection, but by seeking additional sources among his collector friends, including John Rhody, and arduously photocopying these resources for us. Randall exemplifies the belief that "giving is the same as receiving." Thank you to Dr. Edwin Hawk for his inspiring stories of America's personalities. We would also like to thank our friend Rita Lindsey, who shared her collection of photographs and went beyond to find new sources. We thank the Zack family for their wonderful family photos of West Brighton and our friends at St. Andrew's, especially Rev. Joanna White, for their continued support.

We will forever be grateful to the Holtermann family, Gladys Barton, Marjorie Fandrei, and historian Marjorie Johnson for their constance; Jim and Ron Star Romano for their very generous giving of photographs and reproductions; our friend Dick Boera for great photos and captions; Marion Coppotelli and the Coppotelli family for wonderful photos and recollections of the family restaurant, Tavern on the Green. Marion's efforts resulted in the presence of photos which otherwise would not have been available to us. We are indebted as well to the Franzreb family of Clove Lake Stables for opening their family album and a laugh-filled afternoon during which Duke, the Dalmatian, added two more to his list of admirers.

INTRODUCTION

Ever since the cave paintings of Lascaux, man has attempted to leave a record of his activities for those who would come after. Leaving such records is equaled only by the avid attempts to find, preserve, and decipher them.

The recording of human activities took a quantum leap with the invention of the daguerreotype. This advance quickly translated into business ventures, as photographic studios opened to accommodate what seems to be a universal need to leave our successors with a visual record of our presence. People in Staten Island did not lag behind in the craze to enjoy the wonderful new invention. One of the first on Staten Island was the traveling photographer John E. Lake in the late 1870s and 1880.

It is interesting to note that one of the foremost early photographers, Matthew Brady, whose photography provides a visual history of the Civil War, resided for a period of time on Grymes Hill. However, there seems to be no evidence that Staten Island ever became the object of his photographic talents. Dr. John Draper, who lived on Staten Island, has been credited with developing a process considered superior to that of Daguerre. One particularly prolific, early Staten Island photographer was George Bear of Stapleton, whose name graces many of the early portraits of social gatherings on Staten Island.

While Staten Island has been blessed with those who sought to leave of written record of her history, there has also been a broad spectrum of photographic talent, from well-known Alice Austen to home photographers who captured scenes that left "documentation" of life on Staten Island. In a 1951 interview with Oliver Jensen, Alice Austen ascribed her success to "Luck, just Greenhorn luck." While Austen received accolades from the Smithsonian Institution, which praised her work as an overview of upper middle-class doings in the 19th century, it seems her camera was not limited by social class. Her scenes range from elaborately staged tableaux of upper-class life to immigrants at Manhattan's Battery Park and troop ships returning from World War I (WWI).

Each of the photographers has a unique perspective that defines his or her work. For example, William Grimshaw owned a stationery and fountain store and took up the project of photographing numerous Island scenes. Grimshaw reproduced them on postcards and sold them throughout the Island. Percy Sperr owned a bookstore in St. George and produced photographs that have a gothic, mystical quality, and his worked has maintained a following throughout the years. At Sailors' Snug Harbor, resident Edward Clegg recorded life there and referred to his subjects as "my best friends in the world." Bill Higgins captured many subjects of historical

importance. Jim Romano, who took up photography while recovering from an illness, has missed few, if any, events in the Island's history over the past 30 years.

Not to be forgotten or overlooked is the importance of the home photographers, whose cameras capture the essence of everyday life that makes up the very core of local history.

One

THE WILD WEST

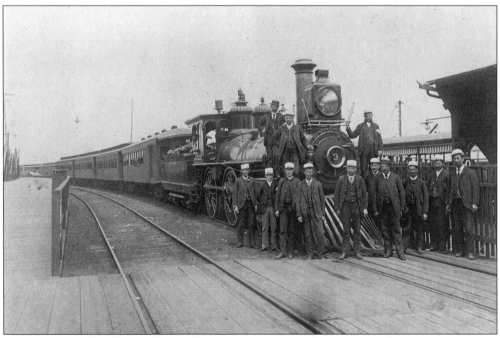

In 1886 or 1887, the "Buffalo Bill Express" transported visitors to the Erastina to view performances of "the Wild West Show" arranged by Erastus Wiman, president of the Staten Island Amusement Company. In exchange, Buffalo Bill agreed to build 4 miles of track from St. George to Erastina, in Mariners Harbor, which was bounded by Union and Van Pelt Avenues. Wiman was Staten Island's answer to P.T. Barnum and Cecil B. DeMille, as he staged extravaganzas such as "The Fall of Rome." Wiman, a major proponent of Staten Island's development, felt that Staten Island's development was contingent upon building an efficient system of transportation. (Collection of the Staten Island Historical Society.)

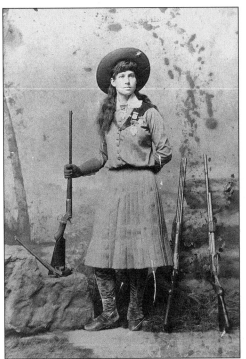

Annie Oakley, one of the stars of the Wild West Show, was born Phoebe Anne Oakley Mosee in Darke County, Ohio, in 1860 to Quaker parents. From an early age, Phoebe showed astonishing ability as a sharpshooter. She competed with marksman Frank Butler and won. In a classic case of "if you can't beat 'em, join 'em," Frank and Annie married. Some of Annie's notable feats included shooting holes in playing cards tossed in the air and shooting cigarettes out of people's mouths. By the time of the Erastina tour, Annie, known as the "Peerless Wing and Rifle Shot," faced the rivalry of a younger woman. Rather than miss the opening day parade and be upstaged by her rival, Oakley attended the parade with a high fever and ear infection. Afterward, Annie fainted and was carried to the ferry. She appears to be the ultimate victor in American hearts. More than 100 years later, her life is still being celebrated in the Broadway revival of "Annie Get Your Gun." (Collection of the SIHS.)

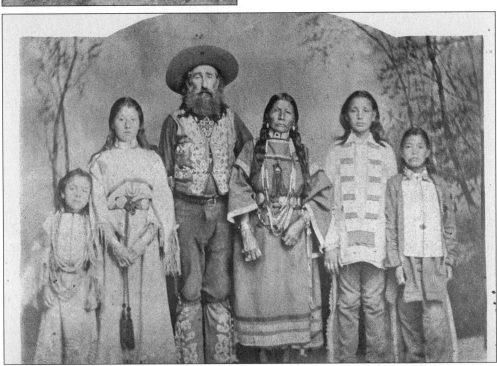

Shown here is a cabinet card of Buffalo Bill's Wild West Show at Erastina in 1886. The group of children and man and woman were photographed by Belknap in New Brighton. Many Staten Islanders alive at that time remember the visits of the Wild West Show and found one of the high points the opportunity to meet with talk with the performers. (Collection of the SIHS.)

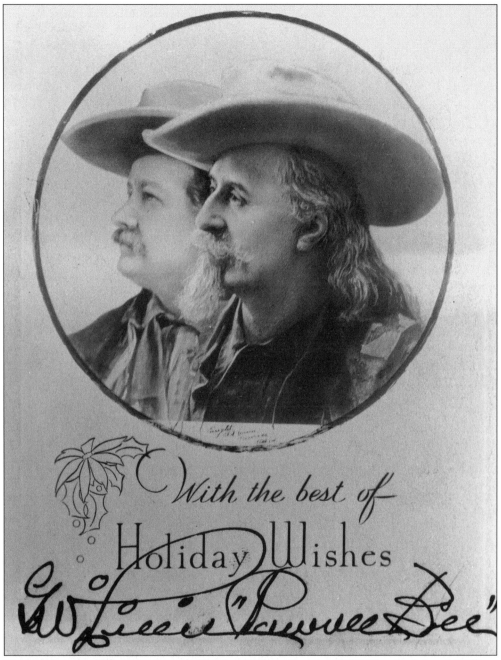

With the best of

Holiday Wishes

This card reads, "With the best of Holiday Wishes, Pawnee Bill." The exploits of William Butler Cody, pictured on the right with a goatee, came to the attention of the American public when he became the subject of the popular dime store novels by Ned Buntline. Born in LeClair, Iowa, in 1846, Cody began his adventures at age 14 when he rode for the Pony Express. He earned the nickname "Buffalo Bill" after he reportedly killed 4,000 buffaloes as part of a commission to provide meat for railroad workers. The show staged train robberies, Indian fights, and buffalo hunts for spectators. (Collection of the SIHS.)

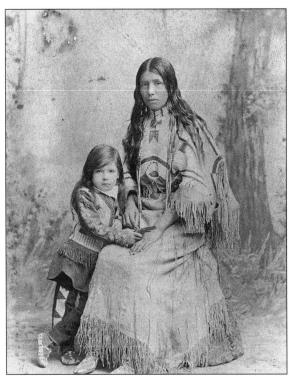

Here is a cabinet card of Buffalo Bill's Wild West Show at Erastina. Ellie Irving, Sioux princess, and her son, Bennie, are pictured here. Newspaper headlines read, "Staten Island Trembles Beneath the Tread of Painted Warriors on the War-Path." The *Richmond County Gazette* recorded performances from June 25, 1886, to May 1888, averaging 15,000 visitors per day. (Collection of the SIHS.)

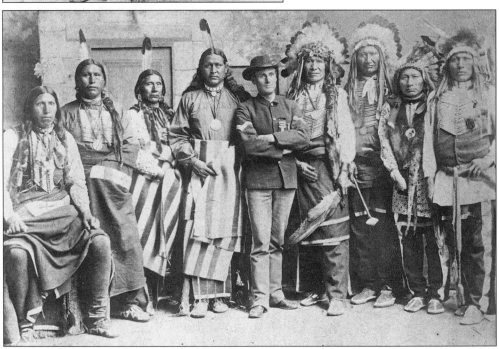

Here are members of Buffalo Bill's Wild West Show. Pictured from left to right are the following: head chiefs of the Pawnee Nation, Eagle Chief, Knife Chief, Brave Chief, Young Chief, and Sargent Bates; head chiefs of the Sioux Nation, American Horse, Rockey Bear, Long Wolf, and Flies Above. (Collection of the SIHS.)

Bennie Irving, who was billed as the smallest cowboy in the world, was also part of Buffalo Bill's Wild West Show. The show went on to tour Europe and returned to Erastina for a few seasons. (Collection of the SIHS.)

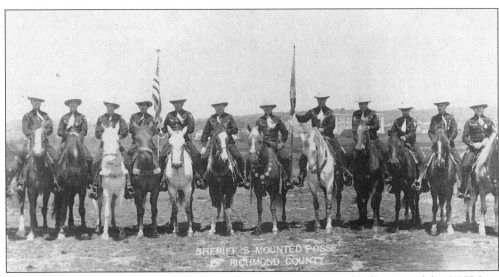

Shown here is the Sheriff's Mounted Posse of Richmond County. (Collection of the SIHS.)

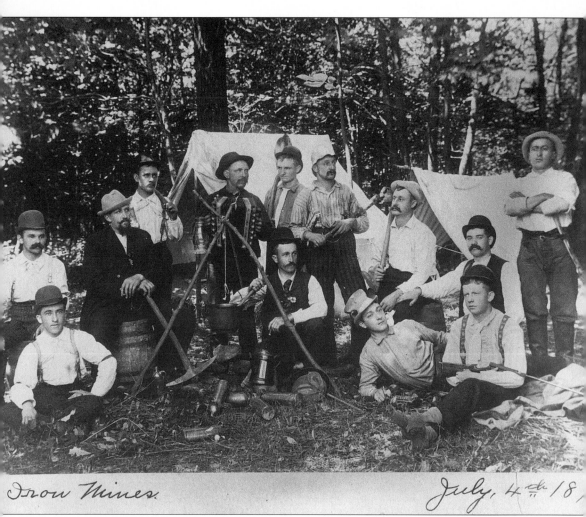

Iron Mines. *July, 4th 18,*

This card is labeled the Iron Mines, July 4, 1890. Although the location of the scene is not stated, the Staten Island Resource Manual notes that Daniel J. Tysen owned iron mines on Todt Hill and Jewett Avenue. Davis and Leng note that another name for Todt Hill was Iron Hill. The mines produced about 120,000 tons annually, which were sold to Bethlehem Steel and Pennsylvania Steel Company. These companies purchased a mine in Cuba from which they were able to obtain a higher grade of ore. This ended mining on Staten Island. (Collection of the SIHS.)

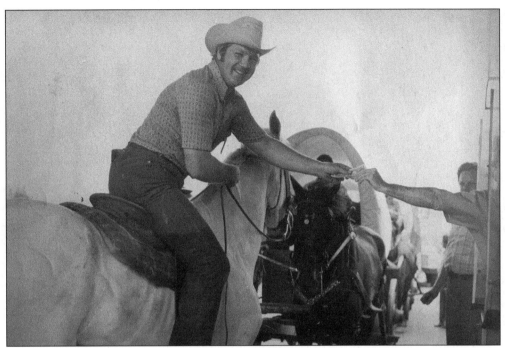

Here, a conestoga wagon crosses the Verrazano Bridge. In honor of the nation's bicentennial celebration, two Conestoga wagon, built by the Franzreb family, departed from Gravesend, Brooklyn, to arrive in Valley Forge. The wagons were the first horse-drawn vehicles to cross the bridge. Here John Franzreb III leans over to pay the toll. (Collection of the Franzreb family.)

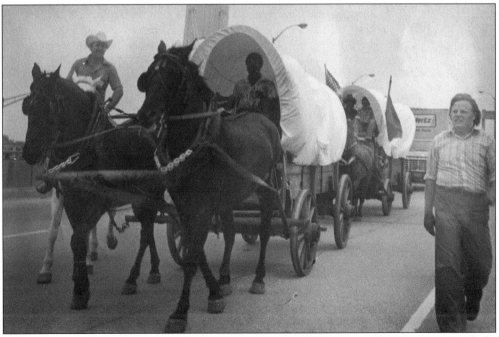

Bill Franzreb, right, walks next to the Conestoga wagons. (Collection of the Franzreb family.)

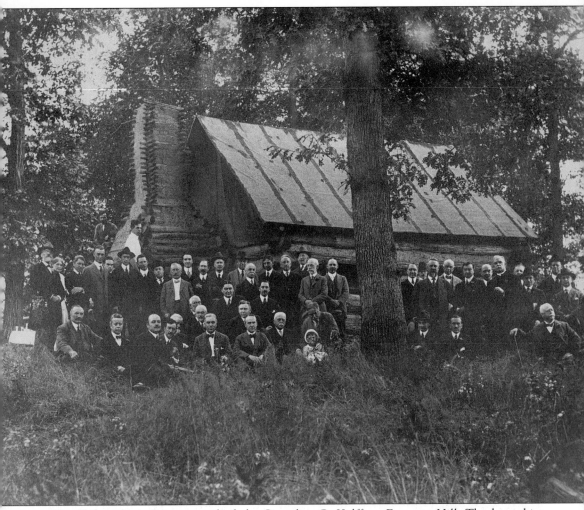

The Philosopher's Retreat was built by Cornelius G. Kolff on Emerson Hill. The log cabin, which measured 22 feet by 11 feet, was destroyed by fire in February 1917. The cabin was erected in the same year as the Woolworth Building and was host to many philosophical discussions. Edwin Markham was among the many participants in these discussions. (Collection of the SIHS.)

Two
THE SPORTING LIFE

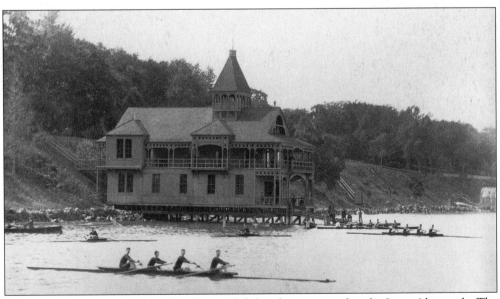

This photo of the Staten Island Athletic Club boathouse was taken by Isaac Almstaedt. The Staten Island Athletic Club was organized in 1877 by William Iken, Oliver T. Johnson, Robert Fiske, Fred and Frank Janssen, John Edwards, and W.J.U. Roberts. In 1881, the boathouse, designed by Staten Island architect Edward A. Sargent, grandfather of Edward A. Johnson, was completed. Historian Bayles noted the boathouse was destroyed by a passing tow and replaced in 1887. (Collection of the SIHS.)

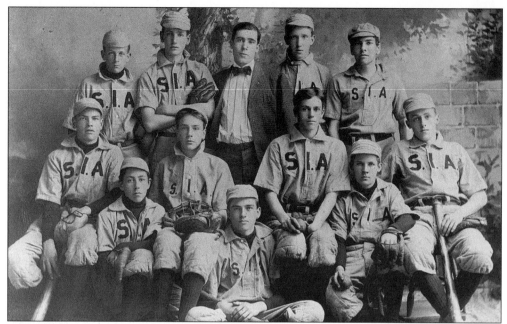

The Staten Island Academy Baseball Team of 1912 is shown here. Pictured from left to right are the following (as labeled on the back of the photograph): (seated on the floor) Maurice Van Bueren, Herman Sittick, G. Brophy; (second row) Sidney Wilcox, Arthur Thompson, Ralph Jackson, and Scott; (third row) unidentified, William Stone, unidentified, unidentified, and Henry Wilcox. (Collection of the SIHS.)

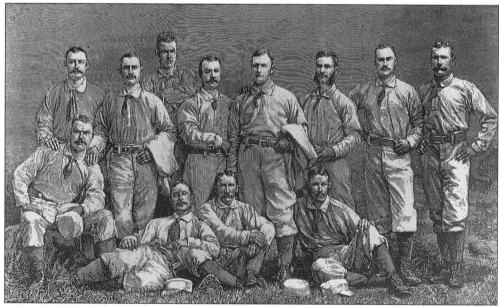

This picture shows the Metropolitan Baseball Nine. Pictured standing are John H. Lynch (pitcher), Charles Reipschlager (catcher), J.E. O'Neill (pitcher), Edward Kennedy (left field), J.C. Clapp (catcher), J.A. Doyle, Pl, Frank Haukinsonk 3.1. B. Stephen Brady, F.F. Seated in the front row are Thomas E. Mausell, C.F. Frank Larkin, B. John Nelson, and SS., John Reilly, 1st base. (Collection of the SIHS.)

Bobby Thomson of home run fame signed, "To my friend Dee," for Dominic Coppotelli, the owner of New Dorp's Tavern on the Green restaurant. Thomson, whose home run was the stuff that dreams are made of, became a household name when he hit the home run in the World Series game with the Dodgers. Born in Glasglow, Scotland, Thomson attended Curtis High School and was known as the "Staten Island Scot." Single and living on the Island at the time of the famous series, Thomson frequently had dinner at Tavern on the Green with his mother. On the famous day, Thomson returned home by ferry and planned to meet his mother for dinner. He was met instead by a surprise party of 1,600 people organized and hosted by Dee and Marion Coppotelli. Today, Thomson is fondly remembered by many Staten Islanders. He lives in northern New Jersey and served recently as chairman of the Arthritis Foundation. (Collection of the Coppotelli family.)

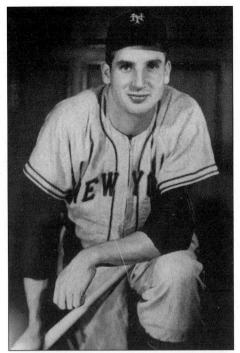

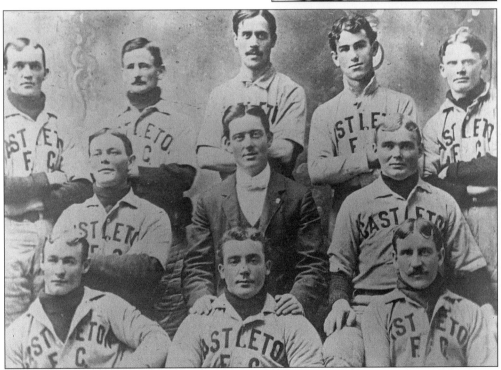

Shown here is the Castleton Baseball Team in 1902. Pictured from left to right are the following: (back row) Willie Kelly, C. Lupton, Neil Collins, Matty McIntyre, and W. Langton; (center) Larry Quinlan, Neil Driscoll, and Jim Graham; (front row) Willie DeForest, Mort Kern, and Bernie Kelly. (Collection of the SIHS.)

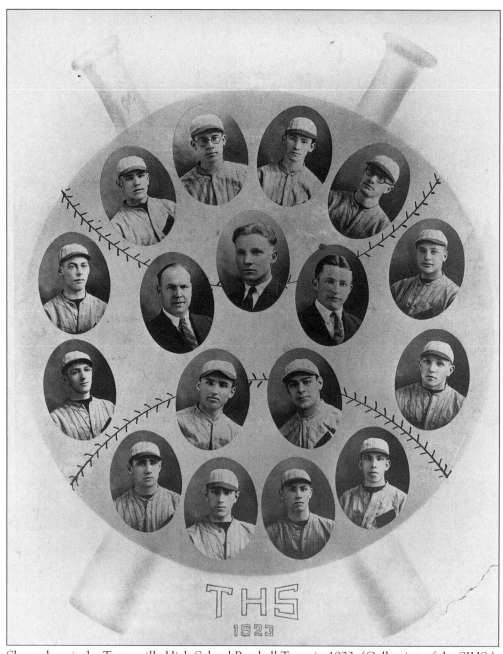

Shown here is the Tottenville High School Baseball Team in 1923. (Collection of the SIHS.)

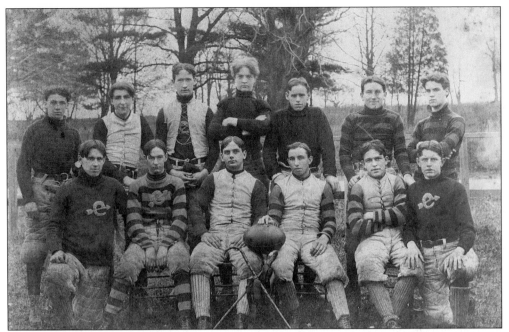

Here is the Corinthian Athletic Club, c. 1895. Their insignia was a "C" with an arrow running through it. At the 1895 Richmond County Fair and Horse Show, the Corinthian Athletic Club competed against the Staten Island Cricket Club in a baseball game. Unfortunately, there is no record of who won. (Collection of the SIHS.)

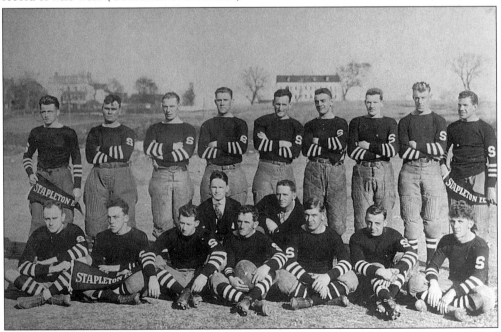

The Stapleton Football Club, organized around 1927, played several games against the New York Giants over the years at Thompson's Stadium in Stapleton. Among its star players was Joe Baeszler (front row, second from right), already a Sandy Hook pilot, who later served as coach of the Augustinian Academy's football teams. (Collection of A. Richard Boera.)

In a pose reminiscent of Knute Rockne, this photo of the football team's long-time coach appeared in the 1932 Augustinian Academy yearbook. The dedication reads, "With deep appreciation for all his valuable assistance in promoting and fostering the spirit of clean athletics, and his generosity in giving his time and services; with admiration for the fine and outstanding qualities of his character and personality which have inspired the wearers of the Maroon and Blue; and with gratitude for all for which we are indebted to him: the 1932 Augustinian is dedicated to Joesph D. Baeszler—a generous benefactor, a fine gentleman, a loyal and true friend." Joe was a Sandy Hook pilot who also served as a commander in the Coast Guard during WW II. His brother, Bill, son Tony, and several uncles and nephews have also been Sandy Hook pilots. (Collection of A. Richard Boera.)

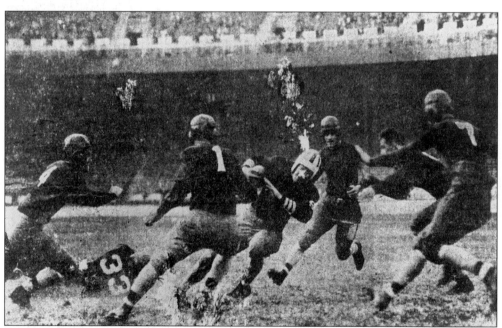

In a 1929 game at the Polo grounds, Doug Wycoff of the Stapes bulls his way through the Giant line for good yardage. (Collection of the SIHS.)

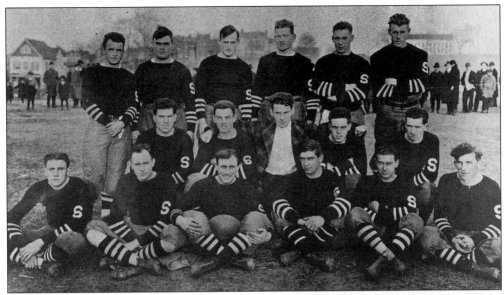

The Stapletons are shown here in 1915. The "Stapes" were one of the original members of the National Football League. According to the Staten Island Resource Manual, Thompson's Stadium, the site of Stapleton Houses, was the scene of clashes among the Stapes, the West Brighton Indians, and the Elm Park Imperials. (Collection of the SIHS.)

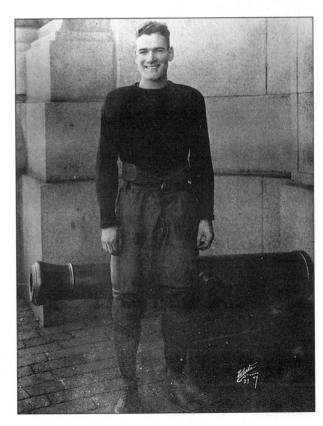

Bill O. Regan, fullback for the Stapes in 1925–26, went on to become an admiral in the U.S. Navy by 1954. (Collection of the SIHS.)

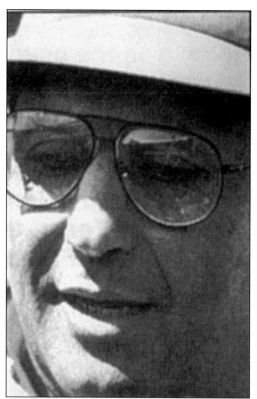

Rich Kotite was named to the first installation of the Staten Island Sports Hall of Fame in 1995. Kotite, who started his sports career in boxing, was a sparring partner for Muhammad Ali. While at Wagner College, Kotite was twice a Little All-American and a star of the Seahawks. He played professional football for six seasons with the Giants, Vikings, and Steelers. Kotite became head coach for the Philadelphia Eagles and New York Jets. (Collection of Margaret Lundrigan.)

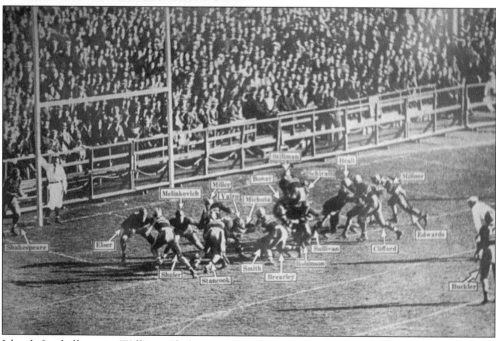

Island football great William Shakespeare is shown at the far left. Shakespeare showed outstanding talent while at Port Richmond High School. He went on to Notre Dame, where his success continued. (Courtesy of the Port Richmond High School Archives.)

In this turn-of-the-century photo, young athletes are identified, from left to right, only by last names: (standing) Waterman, Barto, unidentified, and Gillis; (seated) Ostrom, King, and Jarvis. (Collection of the SIHS.)

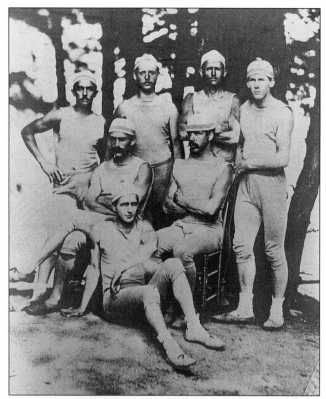

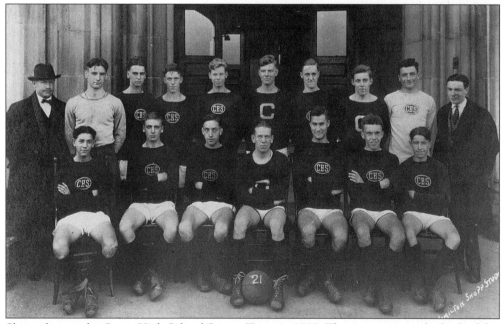

Shown here is the Curtis High School Soccer Team in 1923. The signatures on the back of this image are by Sylvester McGrath, H.F. Boos, Russell Phillips, Harold Cortelyou Sequine, Gordon Schutzenderf, John A. Morris, Donald B. Kennedy, and Clarence J. Beckman. This photo was taken by the Hamilton Shopp Studios. (Collection of the SIHS.)

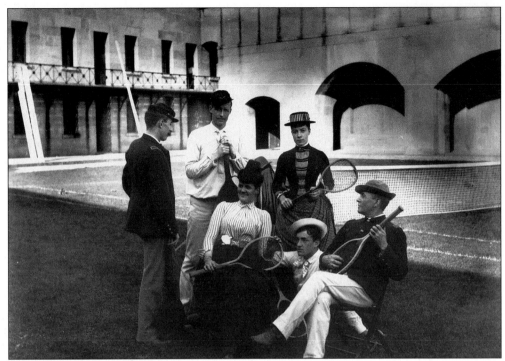

Alice Austen notes: "Group of officers, Trude and self at Fort. Fine clear day, 1:20 p.m. Tuesday November 6, 1888. (Carbutt High blue label, Perkin lense, Stop 22, 11/2 secs.)" Miss Austen is wearing a hat with vertical striped on the band. (Collection of the SIHS.)

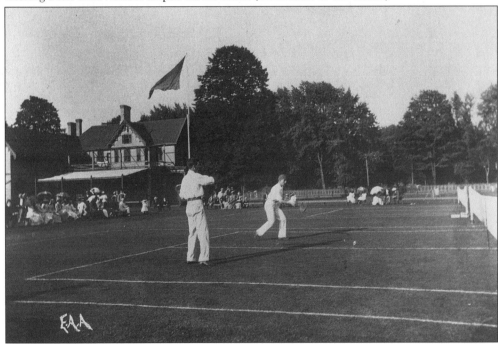

Alice Austen photographed Fred Huntington and Birch. The photo is initialed E.A.A. and dated 1890. Miss Austen notes, "Fine day." (Collection of the SIHS.)

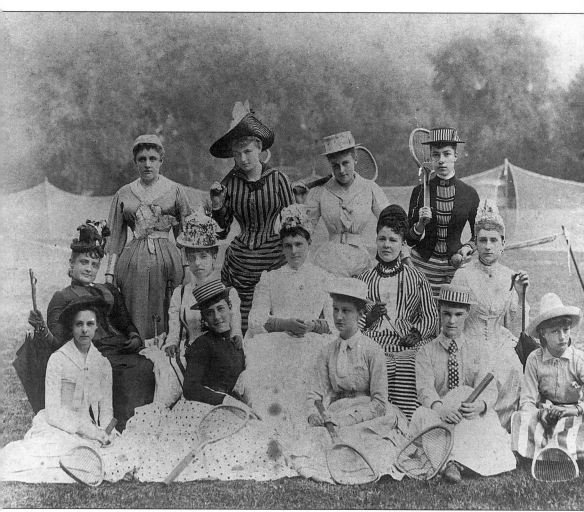

The Staten Island Ladies Club was photographed by Isaac Almstaedt. Alice Austen said to Oliver Jensen, "I could play tennis almost since I could walk." Not only was Austen an avid player, but she turned her attention to capturing the newly emerging pastime with her camera. She spent much time at the Staten Island Cricket and Baseball Club in Livingston. She traveled to other clubs and won a number of prizes. Austen prevailed upon her indulgent family to set out an irregular court on the grounds of their home, Clear Comfort, for the enjoyment of Alice and her friends. (Collection of the SIHS.)

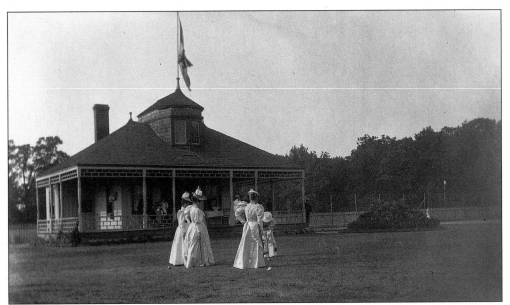

Pictured here is the Clifton Tennis Club House, Sunday, October 28, 1890. (Collection of the SIHS.)

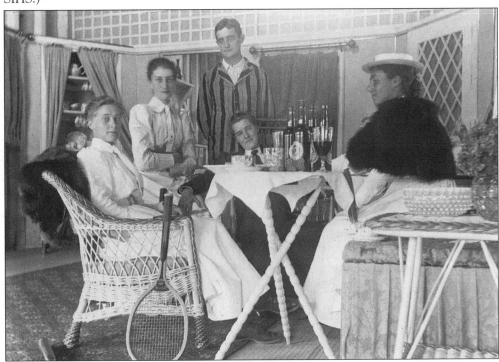

The Roosevelt Sisters are shown here. After winning the finals, the Roosevelt sisters, Grace and Ellen, cousins of Franklin Delano Roosevelt, celebrated with friends. Austen's notation reads, "The Roosevelts, Nellie Jameson, Gertrude Williams, and Rudolph Walker. Lunch party, without dog. Fine clear day, hot, 2 p.m., Sat. Oct. 1, 1892. Stanley 35, Waterbury lense, 12 ft. " Following her marriage to Appleton Clarke, Grace lived at 326 Westervelt Avenue. (Collection of the SIHS.)

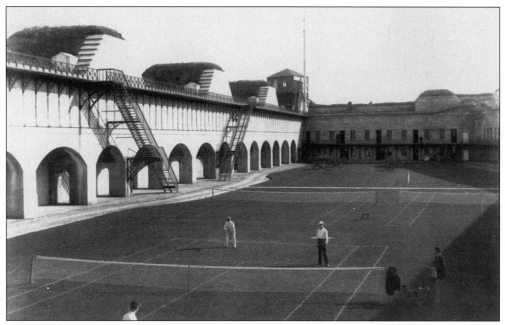

Here is Alice Austen's shot of early tennis inside the battery at Fort Wadsworth. She notes, "Tennis grounds at fort, officers playing. Fine clear day, Sun. 1 p.m." (Collection of the SIHS.)

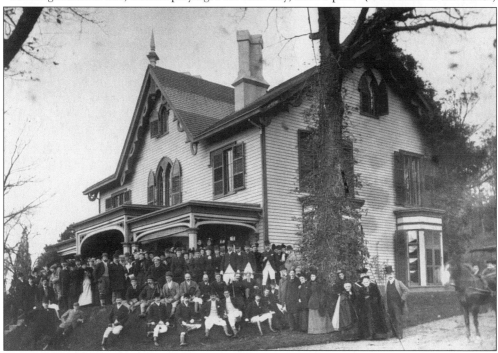

This unidentified hunt group posed for the camera at the Wiman Farm. The hunt was established by the Richmond County Country Club in 1888 at Little Clove Road and Ocean Terrace. Organizers of the club include Eugenious Outerbridge, for whom the Outerbridge Crossing is named. For a number of years, Staten Islanders traveled to Long Island to participate in a hunt. (Collection of the SIHS.)

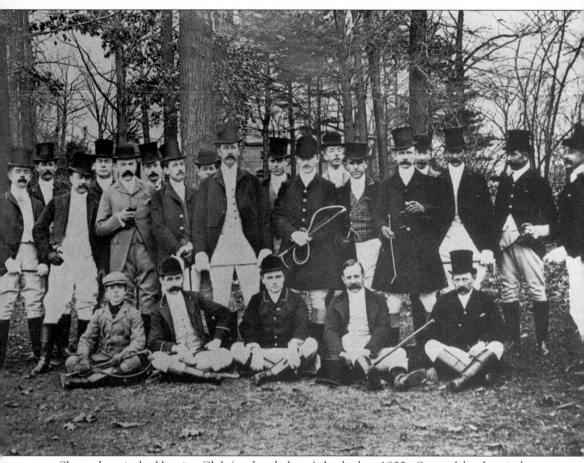

Shown here is the Hunting Club (undated photo). In the late 1800s, Staten Islanders, in hopes of a "Seagoing Hunt," would board a steamer at the New Brighton pier and sail, along with their horses, to Long Island to participate in a fox hunt with the Meadowbrook Club. (Collection of the SIHS.)

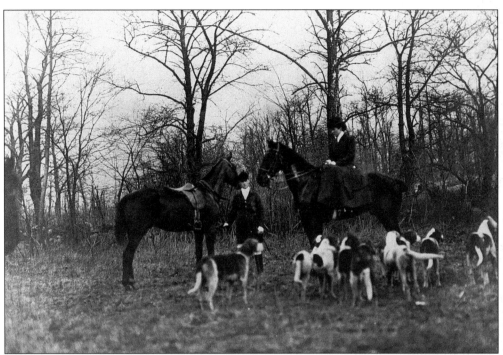

Shown here is hunting at Darcy Farm, Willowbrook. Mrs. Prentice Cooley of Lake Forest, Chicago, is on "Romulus," and Charles Hunt II stands with "Matantie." Island farmers were said to be willing to allow hunt participants to pass over their lands.(Collection of the SIHS.)

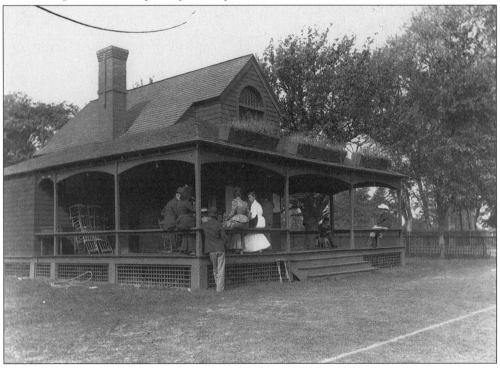

Clifton Clubhouse is pictured here, c. 1890. (Collection of the SIHS.)

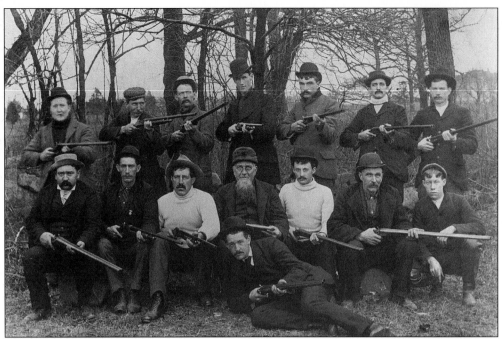

Shown here is the Castleton Gun Club. Pictured from left to right are the following: (front row) Bill Alsten, John Houseman, George Smith, Bob Sommers, Thomas Geissell, Bill Blake, and Ed Bennett; (in front) DeV. Burgher; (rear) William Witte, Bert Sommers, William Curry, James Bennett, William Blake Jr., George W. Vreem, and Ed Houseman. (Collection of the SIHS.)

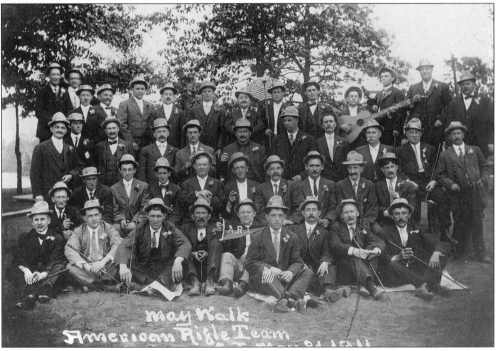

The American Rifle Team May Walk took place in Grasmere on May 21, 1911. (Collection of the SIHS.)

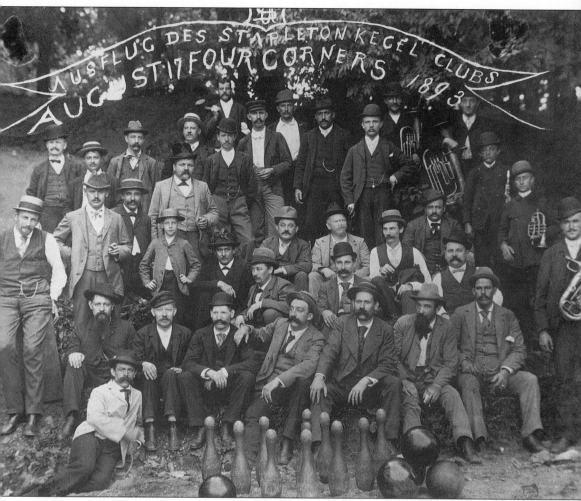

Written on the back of this photograph is "Äusflug des Stapleton Kegel Clubs, at Four Corners on August 17, 1893." By the turn of the century, Stapleton had a large German population, many of whom worked in the breweries and formed a number of fraternal and social clubs. (Collection of the SIHS.)

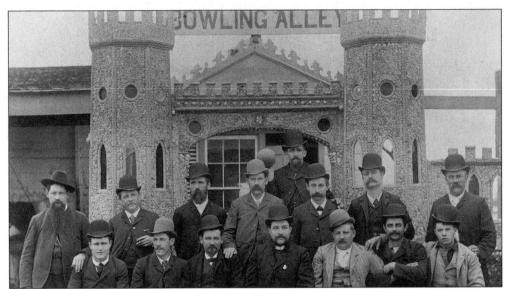

This photo was taken by George Bear in a bowling alley. The gentleman in the light hat pictured in the top row, center is Charles Beinert. On the bottom row, center is Mr. Hein of Willy and Hein, the wheelwrights of Canal Street. Members of the Beinert family were prominent construction contractors, who built many of the island's breweries. (Collection of the SIHS.)

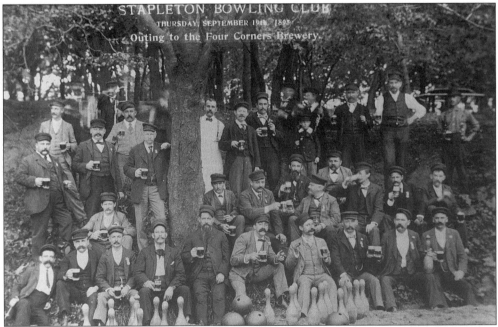

The Stapleton Bowling Club posed on an outing to the Four Corners Brewery on September 19, 1895. Also known as the Constanz Brewery, it was opened in 1852 by August Schmidt and was later purchased by Joseph Setz, before being taken over by Monroe Eckstein. It was located on the present site of Waldbaum's shopping complex. By the late 1880s, the brewery employed about 40 people and was producing 40,000 barrels annually. The brewery was hard hit by prohibition. (Collection of the SIHS.)

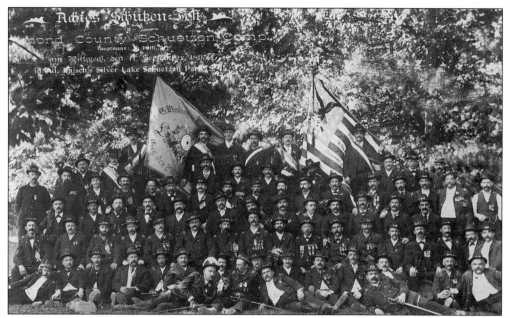

This photo of the Richmond County Schuetzen Camp in Julius Raisch's Silver Lake Schuetzen Park was taken by George Bear and dated September 11, 1895. Bayles notes that in 1872, the Staten Island Schuetzen Corporation was founded by F. Bachmann. (Collection of the SIHS.)

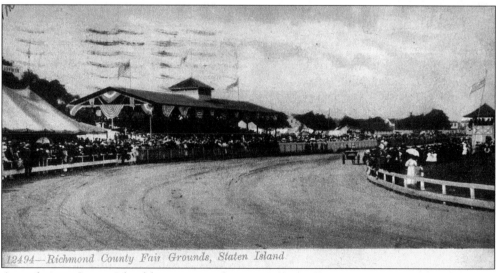

12494—Richmond County Fair Grounds, Staten Island.

According to Staten Island historian Harlow McMillen, "the first annual Richmond County Fair and Horse Show" was held at "The Cove," located at Richmond Terrace and Bement Avenue in West New Brighton from September 2nd to 7th. Billed as "the only fair in New York City," the fair moved in 1905 to the more spacious grounds in Dongan Hills (pictured here), now the site of the Berry Homes. There were prizes awarded in typical livestock and produce categories. Horse events ranged from harness and buggy races to contests between the brewery delivery wagons. Other events included baseball contests and bicycle races. Later additions included a "balloon ascension" by a Professor Kabrich and a Pony and Dog Circus. (Collection of William and Judith McMillen.)

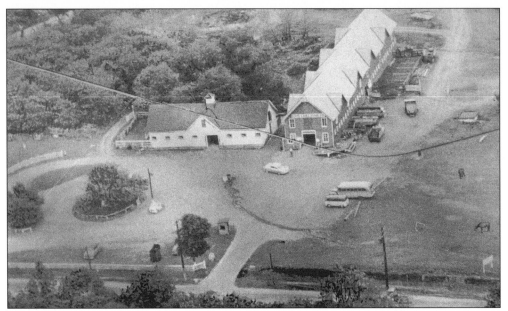

Here is an aerial view of the Clove Lake Stables. The stables usually held about 100 horses, serving the needs of the novice and accomplished equestrian and earning the name of "the incubator of horsemanship." After more than 50 years of serving equestrians, Clove Lake Stables closed in 1983. Today, the site is the location of private homes. (Collection of the Franzreb family.)

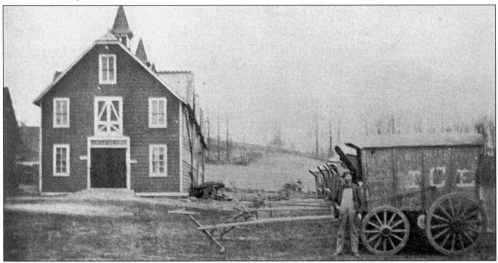

The familiar red barn, seen here when it served as a storage facility for ice harvested from Silver and Clove lakes for the Richmond Ice Company, was a landmark loved by equestrians and Staten Islanders alike. It included the white Dutch Colonial home with its continuous parade and trademark Dalmatians. Clove Lake Stables had its roots in an even older family business—the Hygeia Ice Company. In the days before refrigeration, ice was cut from both Silver and Clove lakes and delivered to local homes and businesses. Ice was stored in a ten-story building located across the street from the red barn, presently the sight of the Fountains apartments, and the Dutch Colonial was an office for the ice business. As refrigeration lessened the need for ice, the family started the livery business. (Collection of the Franzreb family.)

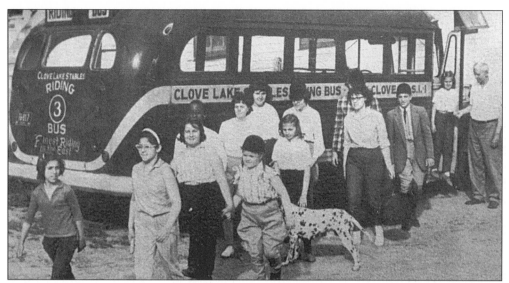

Here people are seen at Clove Lakes, riding bus number three. One of the many services provided by Clove Lake Stables was the after-school riding program that enabled students to come directly from school for riding lessons. Youngsters with a love of horses but unable to afford the price of a ride or the after-school program could still work at the stables. Kids who helped out were treated to an end-of-summer bus trip to Palisades Park with John Franzreb. (Collection of the Franzreb family.)

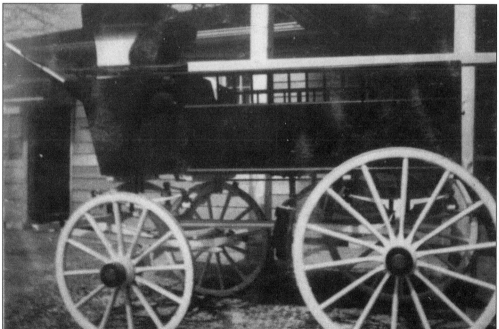

In addition to providing horses for many television shows and movies, Clove Lake Stables supplied the horses and carriages used in the movie *Hello, Dolly*. The carriage seen here is a yellow brake or hacking carriage used by men of means to go into the country for outings such as picnics. Some of the other shows and commercials were "McCloud" and the Colombian coffee commercial. (Collection of the Franzreb family.)

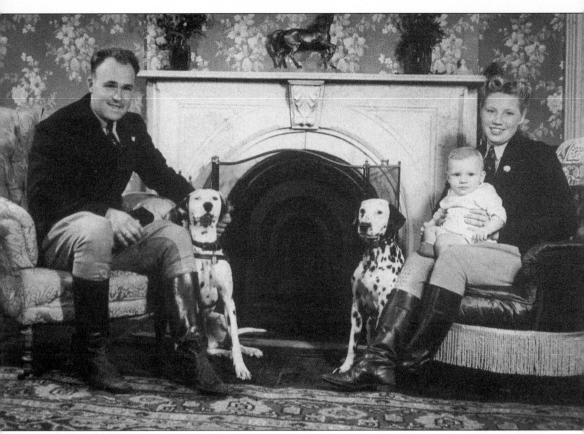

John and Adele Franzreb sit in front of the family fireplace in their home with their son, John III, and the trademark Dalmatians. Mrs. Franzreb, the former Adele Twyford, came from a family with long association with horseback riding. Her grandmother had ridden with Buffalo Bill's Wild West Show when it performed on Staten Island. Adele ran the stables with the assistance of other Franzreb family members while John served in WWII. (Collection of the Franzreb family.)

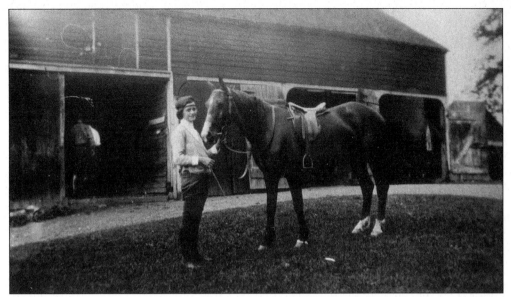

Here is Dick's mother at Franzreb's Stable in 1922. Franzreb's Stables at Clove Lake provided horses and lessons for generations of equestrians. In this 1920 pose, Clara Manz gets ready for a trot with a well-groomed equine rental. (Collection of A. Richard Boera.)

This 1948 celebration of the Cove Inn softball championship took place at Bilotti's Cove Inn on Lafayette Avenue in New Brighton. (Collection of Vincent Lawless.)

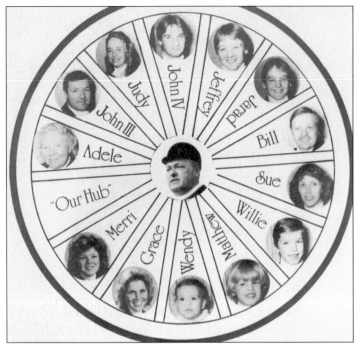

This Franzreb greeting card illustration says, "Yours in Riding for 50 Years," 1933–1982. Long before personalized greeting cards became commonplace, Adele Franzreb created Christmas cards that were unique and memorable. In this card, Adele's children and grandchildren form a circle around John II, who died in 1969. (Collection of the SIHS.)

The 75th anniversary of tennis in the United States is shown here. In 1874, Mary Ewing Outerbridge, sister of Eugenious H. Outerbridge for whom the Outerbridge Crossing is named, returned from a trip from Bermuda and introduced lawn tennis on Staten Island. Miss Outerbridge convinced the Staten Island Cricket and Baseball Club to set up a court at Camp Washington in St. George. In 1880, this site hosted the first national tennis championship in the country. This anniversary shot was taken at the Clifton Tennis Club. Pictured left to right in 1950 are Edward Johnson, Jean Randall, Marilyn Kammann, and Hart Lehman. (Collection of Marjorie Johnson.)

Photographer Jim Romano holds a poster announcing stock car races at Weissglass Stadium. (Courtesy of the Jim Romano Collection.)

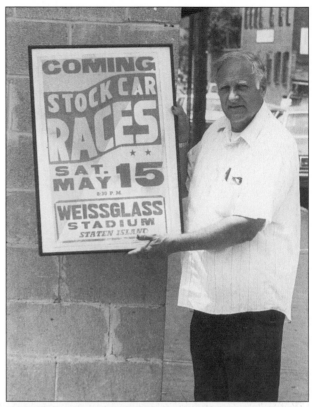

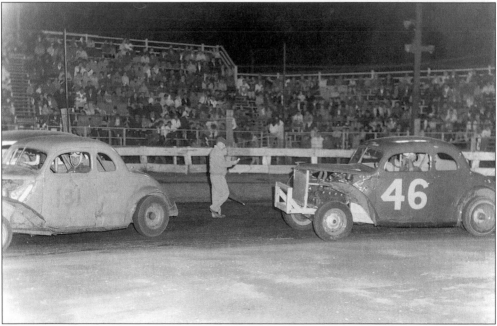

In the 1950s, daredevils made Weissglass Stadium the scene of many sporting events from the exciting stock car races to football games. The stadium was originally called Sisco Stadium. (Courtesy of the Jim Romano Collection.)

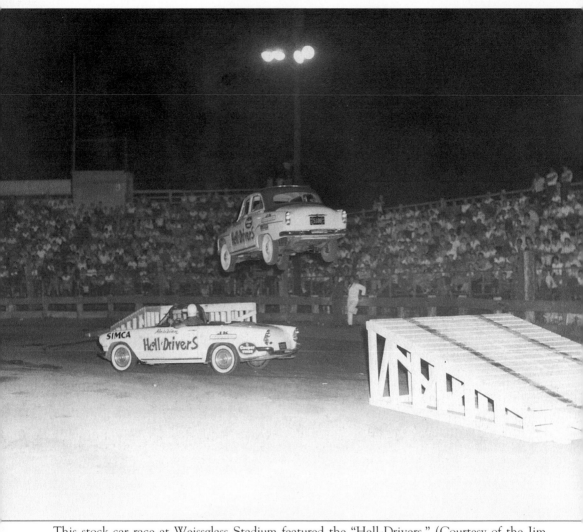

This stock car race at Weissglass Stadium featured the "Hell-Drivers." (Courtesy of the Jim Romano Collection.)

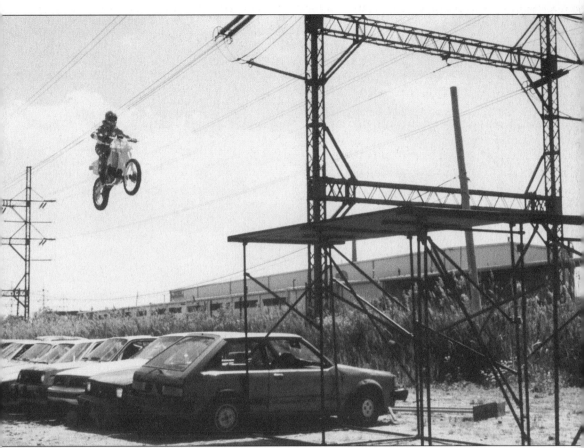

Ron Star Romano vaults 16 cars in a death-defying leap reminiscent of the actions of his hero, Evel Knievel. (Courtesy of Ron Star Romano.)

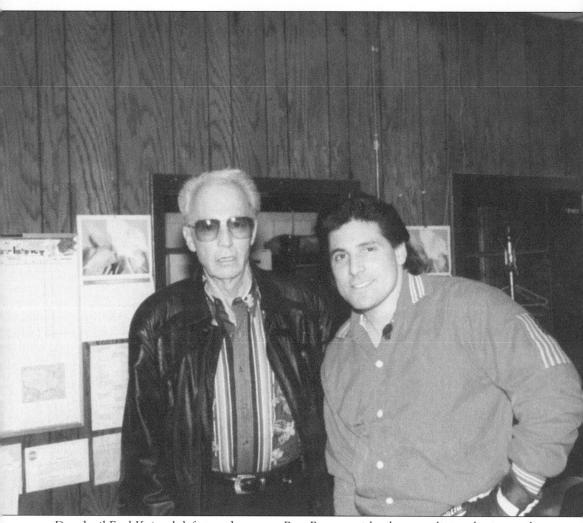

Daredevil Evel Knievel, left, stands next to Ron Romano, island personality and motorcyclist, during a visit to the island. (Courtesy of the Jim Romano Collection.)

Three
PERSONALITIES AND FAMOUS VISITORS

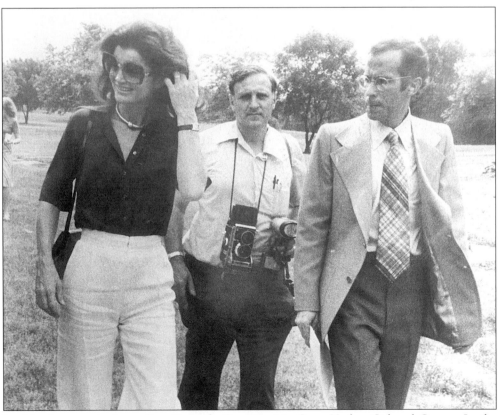

In this photograph, Jacqueline Kennedy Onassis visits Snug Harbor Cultural Center. In the center is Jim Romano, and Barnett Shepherd, Snug Harbor director, is on the right. (Courtesy of the Jim Romano Collection.).

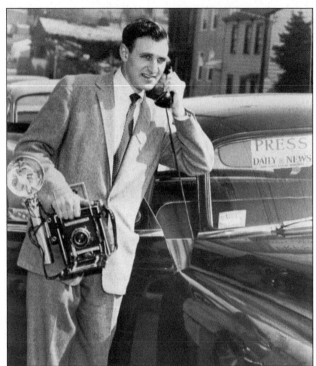

Jim Romano stands beside a press car. Romano, who took up photography while recovering from an illness, has photographed presidential candidates including Dwight D. Eisenhower, John F. Kennedy, and Richard Nixon and covered events from the tragic plane collision in the early 1960s to far happier events such as the Travis parade and stock car races at Weissglass. Romano is responsible for so many of the wonderful photos of Staten Island from the 1940s to today.

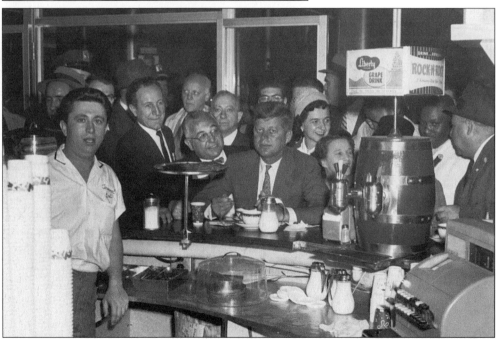

Presidential candidate John F. Kennedy is pictured at the ferry terminal restaurant. Usually photographed with a movie-star-like smile, this photo captures Kennedy with what looks like an uncharacteristic case of "campaignitis." Kennedy took the island by storm, and according to *The Advance*, while at the restaurant, he ordered coffee and a bowl of soup. (Courtesy of the Jim Romano Collection.)

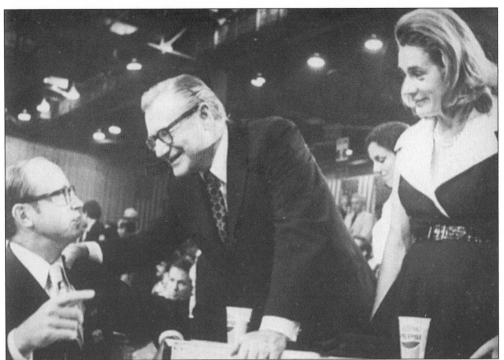

Nelson Rockefeller, governor of New York and member of the wealthy Rockefeller family, appears here with his second wife, Happy. Following a scandal that involved Happy, Rockefeller divorced his former wife to marry Happy. (Collection of the Coppotelli family.)

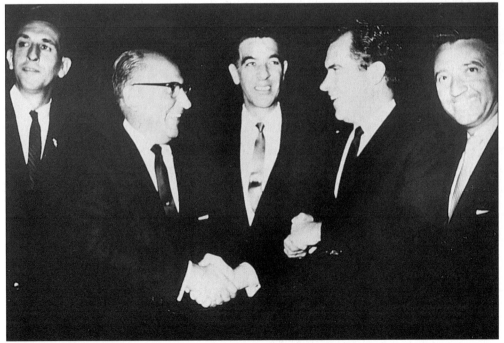

Richard Nixon poses here with Congressman Frank Biondolillo, who is shaking Nixon's hand. Joe Sciacca is pictured on the right. (Collection of the Coppotelli family.)

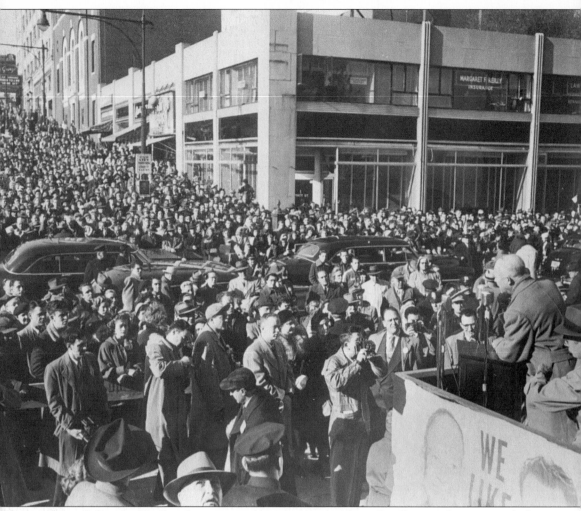

General Dwight D. Eisenhower, on the campaign trail in St. George, leans toward the microphone to address the large crowd. The campaign motto "We Like Ike" is visible on several posters. Also appearing in the background at 1 Hyatt Street are the law offices of Herman Methfessel and Bernard Curley and the insurance offices of Margaret Reilly. The St. George Marquis announces that actress Jean Simmons is appearing in "Clouds Yellow" followed by a double-feature, "Sound Off." (Courtesy of the Jim Romano Collection.)

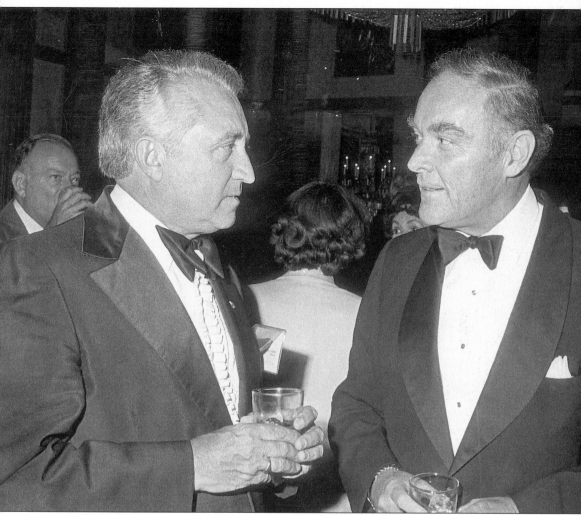

Joe Sciacca, with General Alexander Haig, posed at a testimonial dinner in 1990. Sciacco, born on Cherry Street in Lower Manhattan, came to Staten Island at a very early age. Throughout his life, he was active in the Republican Party and served as commissioner of sports for 17 years. Well known during the infamous Watergate Hearings of the Richard Nixon administration, Haig served as Nixon's Chief of Staff. (Collection of Joseph Sciacca.)

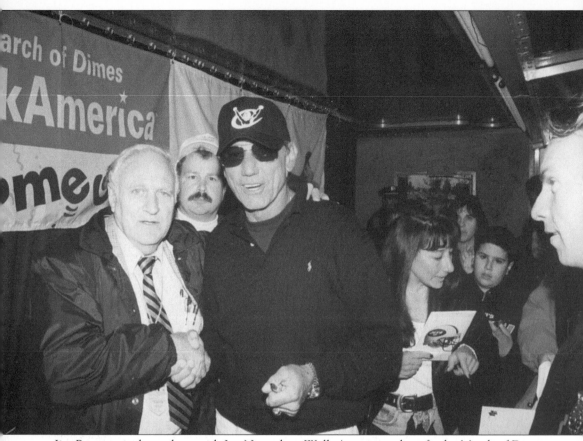

Jim Romano is shown here with Joe Namath at Walk America to benefit the March of Dimes. (Courtesy of the Jim Romano Collection.)

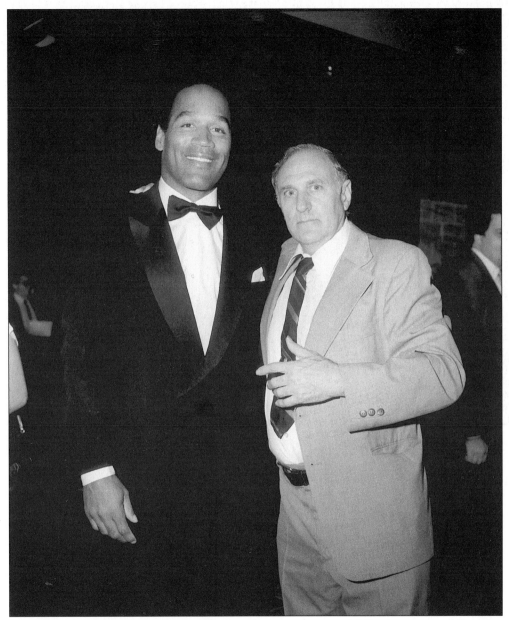

Jim Romano posed with O.J. Simpson before Simpson went on trial for the murder of his wife, Nicole and her friend Ron Goldman. After a highly publicized and controversial trial, Simpson was acquitted. (Courtesy of the Jim Romano Collection.)

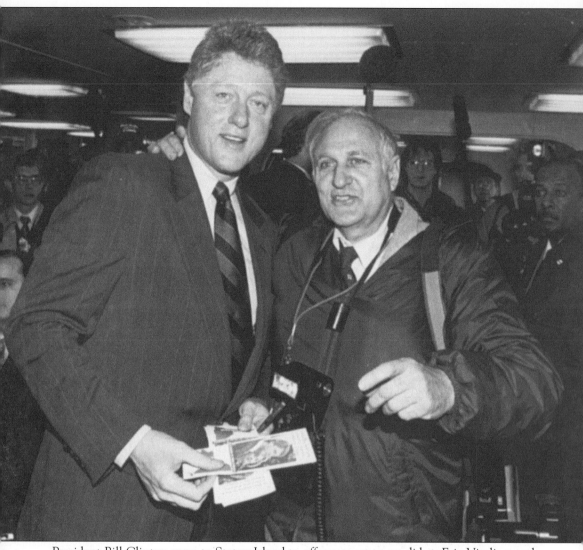

President Bill Clinton came to Staten Island to offer support to candidate Eric Vitaliano, who was vying for the seat vacated by Susan Molinari. (Courtesy of the Jim Romano Collection.)

Four

PUBLIC WORKS

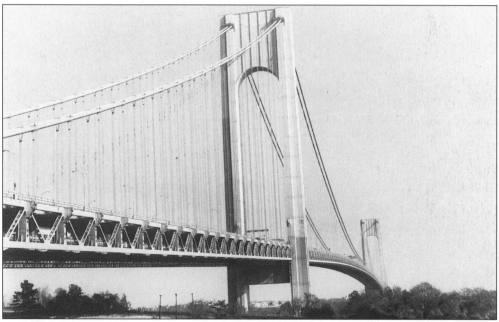

This daytime shot, by Jim Romano, captures the beauty and power of the Verrazano Narrows Bridge. Named for explorer Giovanni Verrazano, the bridge is the magnum opus of the borough's public works. An oft-quoted statistic is that the main cables contain enough wire to encircle the earth five times. At the time of its completion, the bridge was the longest expansion bridge in the world, exceeding San Francisco's Golden Gate by 60 feet. The bridge was completed at a cost of $350 million. Initially, the Staten Island Resource Manual reports that the Army Corps of Engineers objected to the bridge on the basis of strategic consideration: fears that a possible bombing of the bridge would render New York Harbor impassable. An interesting project that might have been was a much-discussed tunnel, linking Staten Island to Brooklyn. In 1921, shafts were actually sunk on both the Staten Island and Brooklyn sides and came to be called "Hylan's holes." The project was never completed. (Courtesy of the Jim Romano Collection.)

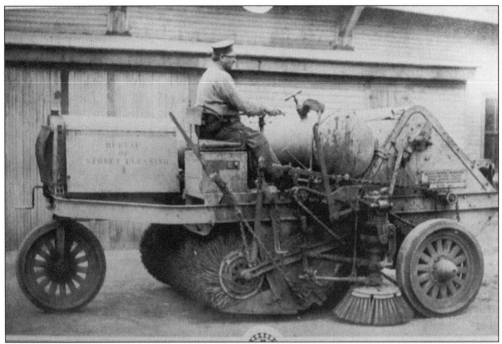

This photograph of a street-cleaning machine, c. 1924, is from the annual report of the borough president in 1924. (Courtesy of A. Richard Boera.)

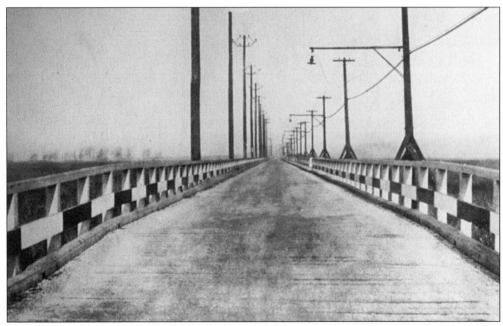

The Fresh Kills Bridge is pictured here in 1924. Borough President Lynch's report projects the need for a larger bridge based on plans for the completion of the Outerbridge Crossing. According to the annual report in 1924, it was anticipated that the Goethals Bridge and Bayonne Bridge would increase traffic on Richmond Avenue. (Courtesy of A. Richard Boera.)

The Garbage Crematory in West New Brighton was erected in 1899 and used until 1908. The borough president's report in 1907 notes, "The West New Brighton Garbage Crematory was continued in operation during 1907 without serious complaint from nearby residents. It is expected that this inefficient plant may be discontinued in 1908." (Courtesy of Randall Gabrielan.)

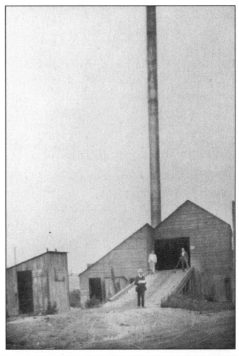

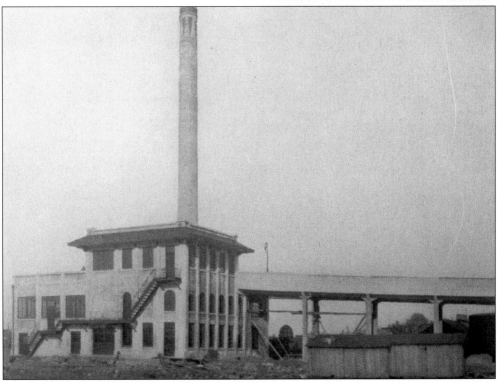

The Refuse Destructor in West New Brighton was erected in 1907. According to the borough president's report, the refuse destructor, built adjoining the crematory, was considered a technological advance over the crematory. (Courtesy of Randall Gabrielan.)

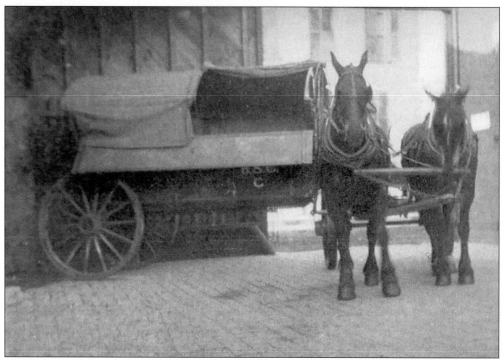

Shown here is a five-yard, bottom-dump, refuse collection wagon with canvas cover. (Borough President's Report.) (Courtesy of Randall Gabrielan.)

This photo of the intersection of Richmond Road, now named Van Duzer Street, and St. Paul's Avenue shows the use of iron slag block. (Borough President's Report.) (Courtesy of Randall Gabrielan.)

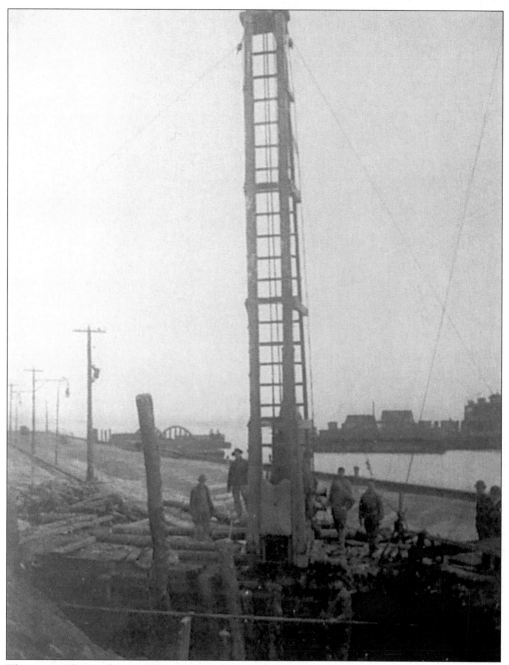

This view shows the building of St. George Ferry Approach at South Street. (Borough President's Report.) (Courtesy of Randall Gabrielan.)

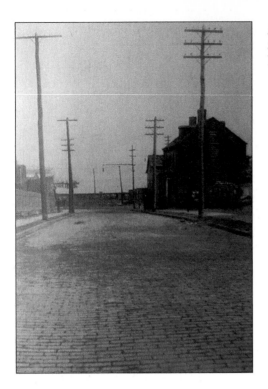

Shown here are Hannah and Sarah Ann Streets in 1907. (Borough President's Report.) (Courtesy of Randall Gabrielan.)

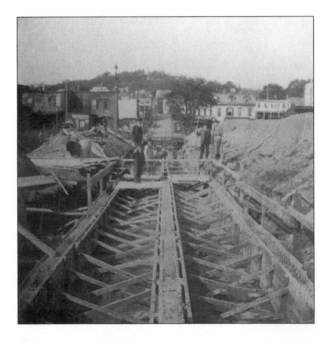

Another extensive public works project during the administration of George Cromwell were sidewalks. Here, one can see the forms used for the sidewalks at the foot of Elizabeth Street. (Borough President's Report, 1907.) (Courtesy of Randall Gabrielan.)

Two well-dressed gentlemen stand by a reinforced-concrete outlet sewer. (Borough President's Report.) (Courtesy of Randall Gabrielan.)

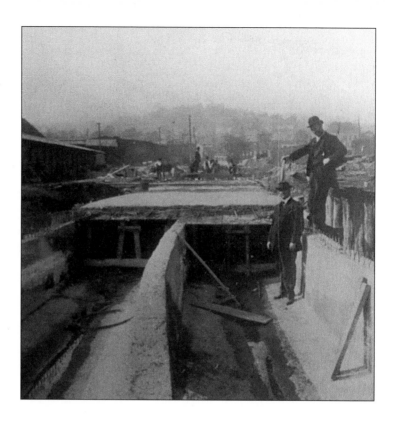

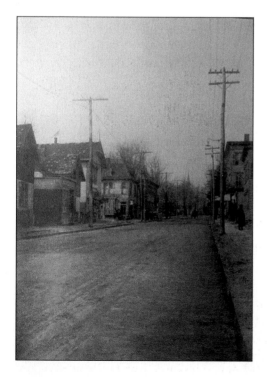

Street paving comprised a large part of the public works during the George Cromwell administration. Bennett Street and Jewett Avenue show the use of vitrified brick. (Borough President's Report.) (Courtesy of Randall Gabrielan.)

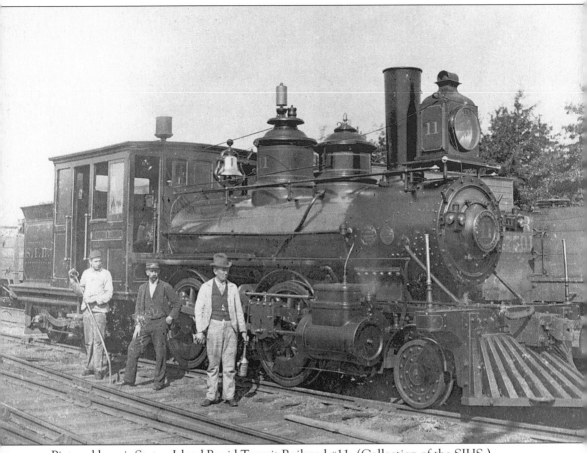

Pictured here is Staten Island Rapid Transit Railroad #11. (Collection of the SIHS.)

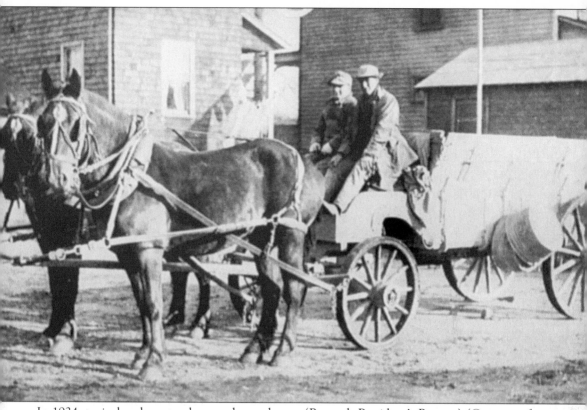

In 1924, typical garbage trucks were horse-drawn. (Borough President's Report.) (Courtesy of A. Richard Boera.)

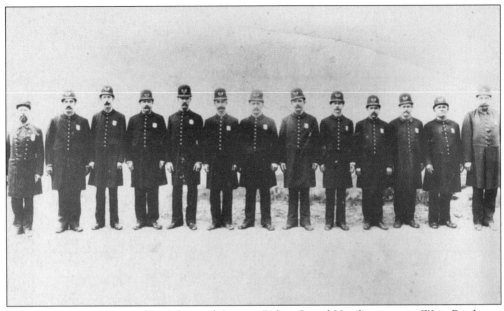

This picture was taken at the Richmond County Police Squad Headquarters in West Brighton, c.1890. The police station was located at 1590 Richmond Terrace in West New Brighton. The only officer identified in this photo is Hugh Conlon at the far right. (Collection of the SIHS.)

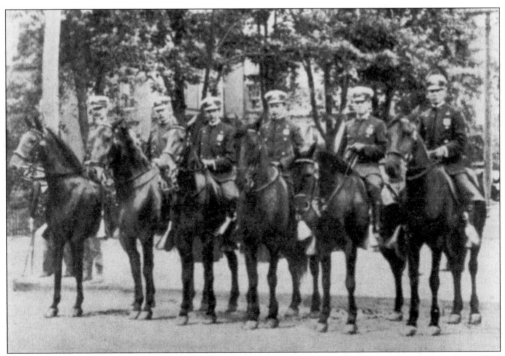

The Staten Island Resource Manual notes that a unit of mounted police was organized in 1895 at Rockland and Forest Hill Roads in New Springville but moved to New Dorp in 1899. (Collection of the SIHS.)

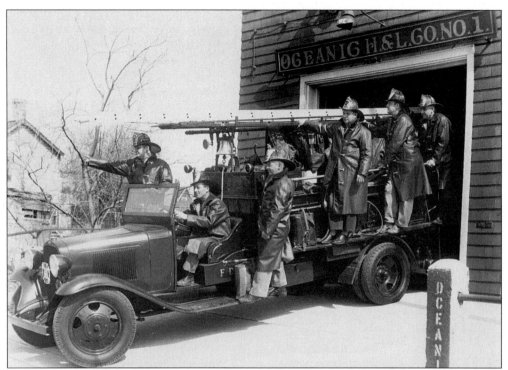

The Oceanic Volunteer Fire Company from Travis was one of only two volunteer fire companies in Staten Island, the other being the Richmond Town Company. The Oceanic shares with the Richmond Town Company the distinction of being one of the two remaining volunteer fire companies in New York City. (Courtesy of the Jim Romano Collection.)

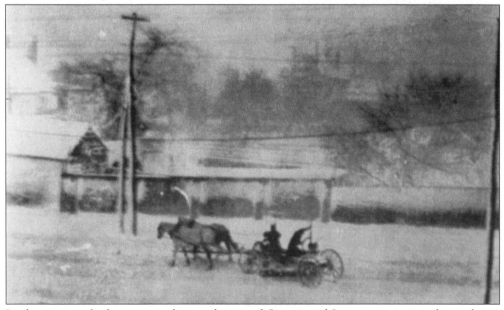

In this scene, which is seemingly straight out of Currier and Ives, two men in a horse-drawn vehicle clear Staten Island streets. (Borough President's Report.) (Courtesy of Randall Gabrielan.)

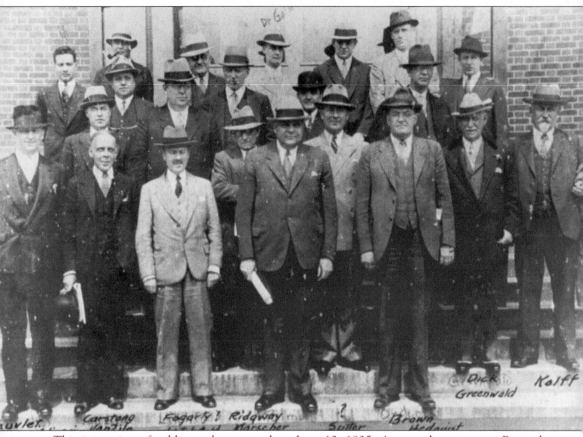

This inspection of public works occurred on June 13, 1935. Among the group are Borough President Palma, center, and Cornelius Kolff. (Collection of the SIHS.)

A photograph taken by Charles Harriman shows the Staten Island-Bergen Point Ferry in the foreground. Visible in the background is the beginning of construction of the Bayonne Bridge. (Collection of the SIHS.)

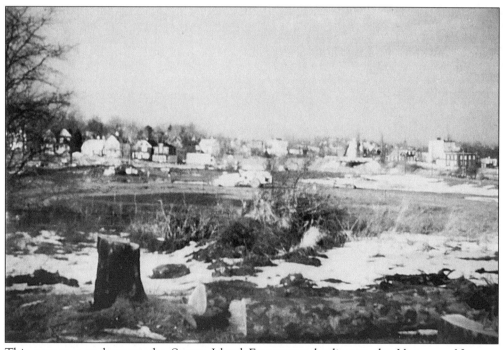

This area was to become the Staten Island Expressway leading to the Verrazano Narrows Bridge. Social critic and writer Lewis Mumford was vociferous in his criticism of the construction of the Verrazano Narrows Bridge, saying it would cost almost as much as the Panama Canal and calling it a "destructive proposal." Mumford was not alone in his belief that the bridge would change the character of Staten Island and displace approximately eight thousand Brooklyn residents. (Collection of Richard C. Winters.)

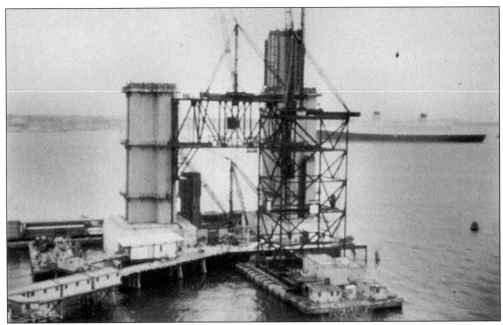

This scene shows the towers of the Verrazano Narrows Bridge under construction with the S.S. France as a backdrop. (Courtesy of Richard C. Winters.)

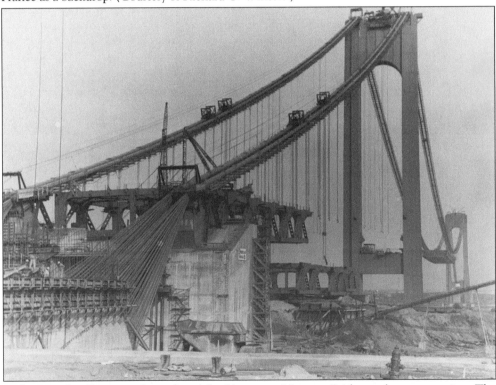

A dramatic Jim Romano photo shows the Verrazano Narrows Bridge under construction. The towers are in place, but the upper and lower decks of the bridge have yet to be completed. (Courtesy of the Jim Romano Collection.)

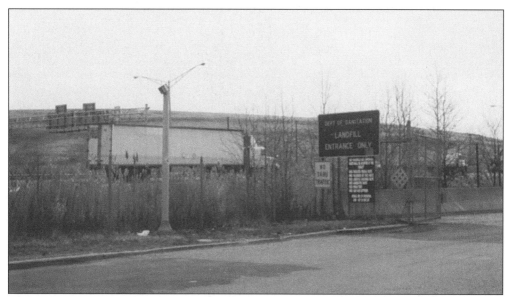

This rather innocuous photo shows the Great Kills Landfill, which over the past 20 years has been one of Staten Island's most hotly debated issues. The landfill that receives garbage from Staten Island and the other boroughs has figured prominently in the vote by Staten Islanders to secede from New York City. Ironically, the desire to obtain more municipal services in 1898 motivated many islanders to vote to become part of the city. When it is finally closed, the landfill will be the highest man-made point on the Eastern seaboard. (Photo by Tova Navarra.)

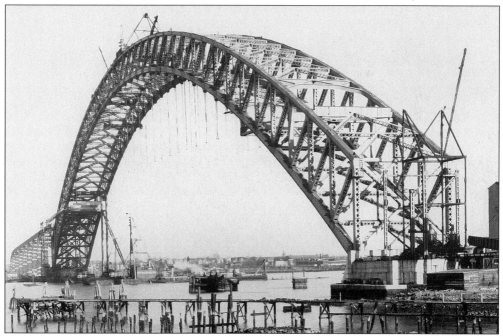

The Bayonne Bridge, under construction, was longer by 2 feet than the much-admired Sidney Bridge and was hailed for its rainbow architecture. Within a span of a few months in 1930, Staten Island became connected to New Jersey by three bridges, the Bayonne, the Goethals, and the Outerbridge Crossings. (Collection of SIHS.)

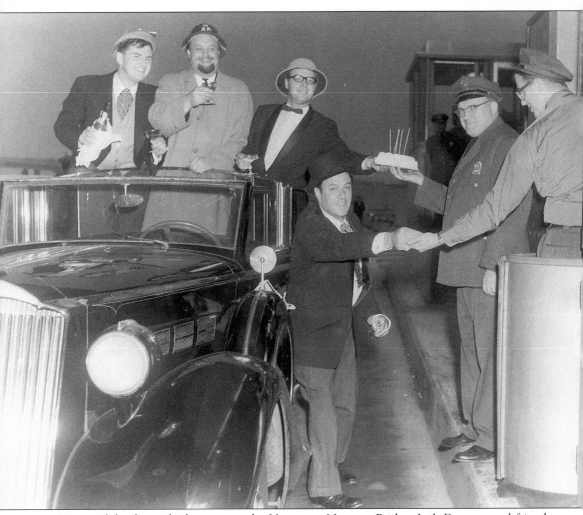

In one of the first vehicles to cross the Verrazano Narrows Bridge, Jack Demyan and friends raise a glass and light candles as they pay the toll. The several restaurateurs were larger-than-life characters whose exploits were known throughout the island. (Courtesy of the Jim Romano Collection.)

Five

BUSINESS

The Gypsum Plant on Richmond Terrace in New Brighton manufactured a variety of plaster-based products including sheetrock. Plaster provided employment to approximately five hundred area residents for decades. The U.S. Gypsum Company took over in 1924 from the Windsor Plaster Mills. Gypsum eventually moved to New Jersey. The site at 561 Richmond Terrace was previously the Jerome B. King Plaster Mill started in 1876. Gypsum rock from Windsor, Nova Scotia, was sent by boat to be made into Sheetrock and other products at the plant. The plant was served by freight trains from the Baltimore & Ohio Railroad. (Collection of the SIHS.)

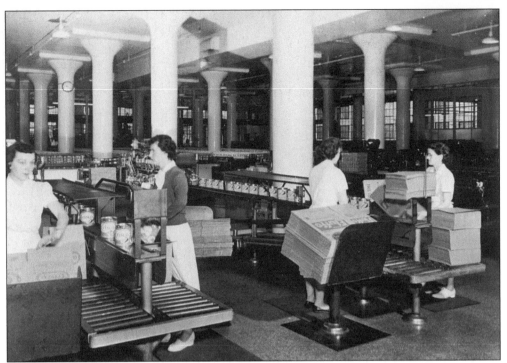

These ladies are on the packing line for Crisco at Port Ivory. (Courtesy of the Procter & Gamble Company.)

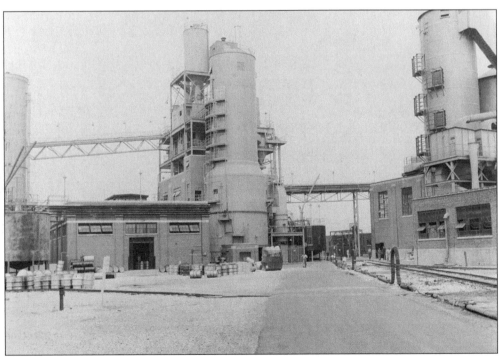

Pictured here is the soap manufacturing building at Port Ivory. (Photo used with permission of the Procter & Gamble Company.)

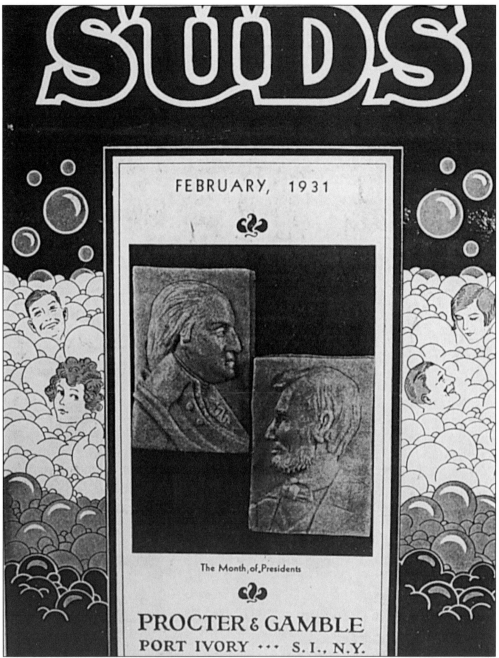

The Procter & Gamble, Port Ivory employee magazine was aptly called *Suds*. The cover of the February 1931 issue honors presidents Lincoln and Washington. The magazine was published during the height of the nation's Depression. This issue carries a story titled, "Our Own Employment Guarantee Plan Broadcast As Model For Nation." Founded by Procter & Gamble, the Port Ivory Plant was the third major plant built by P&G following Ivorydale in Cincinnati, the Kansas City Plant. The company was at the forefront of many labor reforms such as paid sick-time, profit-sharing, and the above-mentioned guaranteed employment. (Collection of Margaret Lundrigan.)

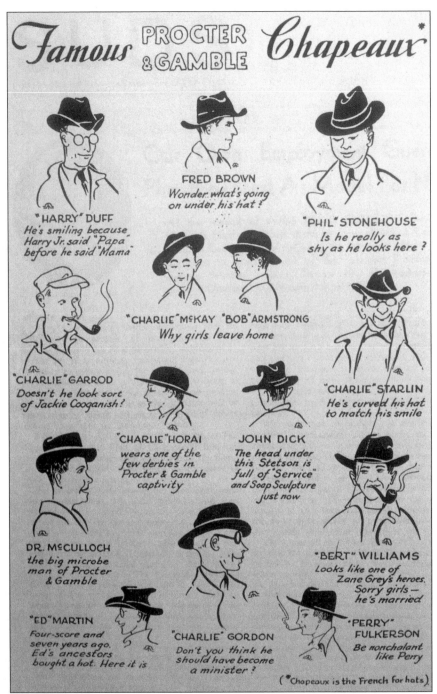

Famous PROCTER & GAMBLE *Chapeaux**

"HARRY" DUFF
He's smiling because
Harry Jr. said "Papa"
before he said "Mama"

FRED BROWN
Wonder what's going
on under his hat?

"PHIL" STONEHOUSE
Is he really as
shy as he looks here?

"CHARLIE" McKAY "BOB" ARMSTRONG
Why girls leave home

"CHARLIE" GARROD
Doesn't he look sort
of Jackie Cooganish?

"CHARLIE" HORAI
wears one of the
few derbies in
Procter & Gamble
captivity

JOHN DICK
The head under
this Stetson is
full of "Service"
and Soap Sculpture
just now

"CHARLIE" STARLIN
He's curved his hat
to match his smile

DR. McCULLOCH
the big microbe
man of Procter
& Gamble

"BERT" WILLIAMS
Looks like one of
Zane Grey's heroes.
Sorry girls —
he's married

"ED" MARTIN
Four-score and
seven years ago,
Ed's ancestors
bought a hat. Here it is

"CHARLIE" GORDON
Don't you think he
should have become
a minister?

"PERRY" FULKERSON
Be nonchalant
like Perry

(*Chapeaux is the French for hats)

From the same issue of *Suds*, came this artistic rendering of famous employees and their "chapeaux," which, as the magazine notes, is French for "hats." In addition to dealing with issues of concern to employees (such as the story on General Procter's addressing the Hoover administration on the benefits of guaranteed employment), it reported special events such as retirements, marriages, births, deaths, and light-hearted and entertaining features such as "The Chapeaux." (Collection of Margaret Lundrigan.)

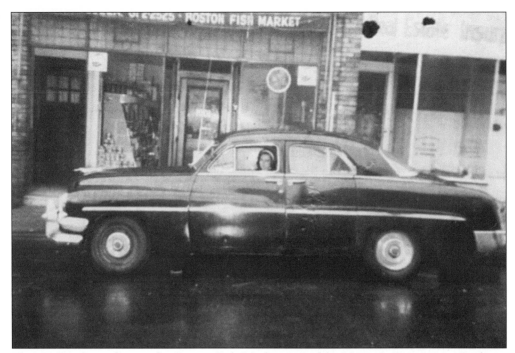

This 1960s photo depicts the Boston Fish Market owned by Vincent Cucuzza on Castleton Avenue, New Brighton. (Collection of Rita Lindsey.)

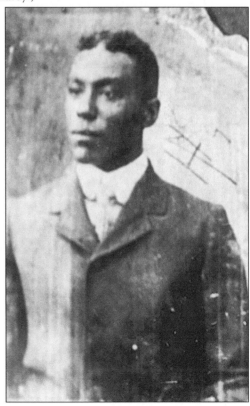

William Morris, who owned Morris Movers, was born in North Carolina and came to Staten Island as a young man. He was one of the first organizers of the Staten Island NAACP and was involved in many civic and church-related activities. The William J. Morris High School was named in honor of his civic achievements and devotion to education. His daughter, Evelyn Morris King, is an educator on Staten Island. She wrote a history of black people on Staten Island that is still used in the schools. (Collection of Evelyn Morris King.)

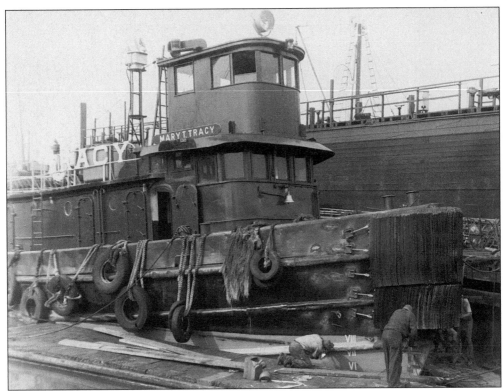

The Mary T. Tracy tugboat, photographed while docked, was one of a number of tugboat companies.

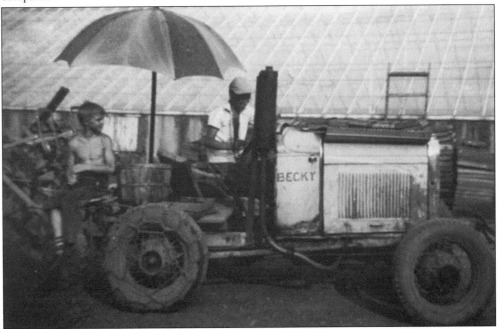

This planting tractor, affectionately named "Becky," had been put together with an old automobile engine on the Mohlenhoff farm in Travis. (Collection of the Mohlenhoff family.)

Mechanic John Zack, an employee of the U.S. Gypsum Company for many years, posed here with some friends in front of a gas pump at the company in the late 1940s. (Collection of Margaret Harris Zack.)

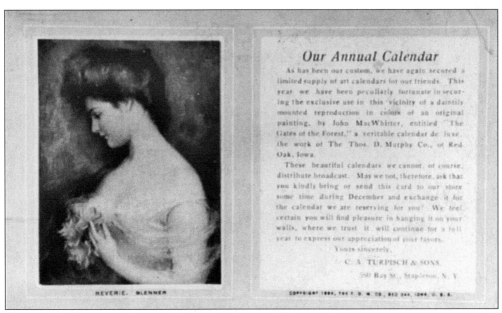

This card, with a reproduction of a painting entitled "Reverie," was sent to customers by C.A. Turpisch & Sons, located at 880 Bay Street in Stapleton. Customers could redeem the card for a complimentary calendar. (Collection of Randall Gabrielan.)

75

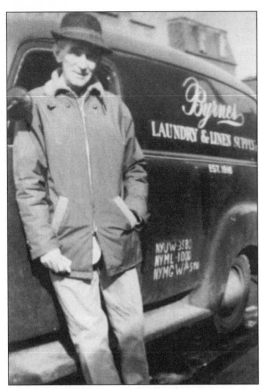

Joe Byrne of Byrne's Laundry & Linen Supply stands next to the company delivery truck. The company was established in 1916 by Owen Byrne and was run for many years from a store on Castleton Avenue. The business continues to be family-operated. (Collection of Rita Lindsey.)

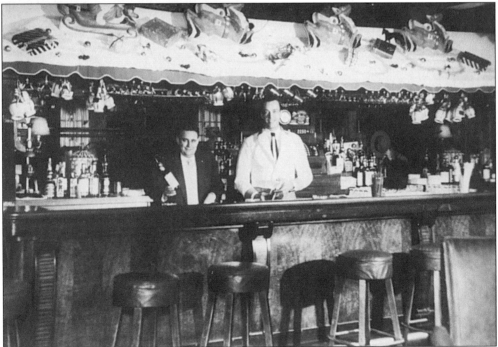

Dominic "Dee" Coppotelli (left) stands with a bartender at the festively decorated bar of The Tavern on the Green. Before purchasing the restaurant, the Cappotelli family owned a fruit and vegetable market on Richmond Road. (Collection of the Coppotelli family.)

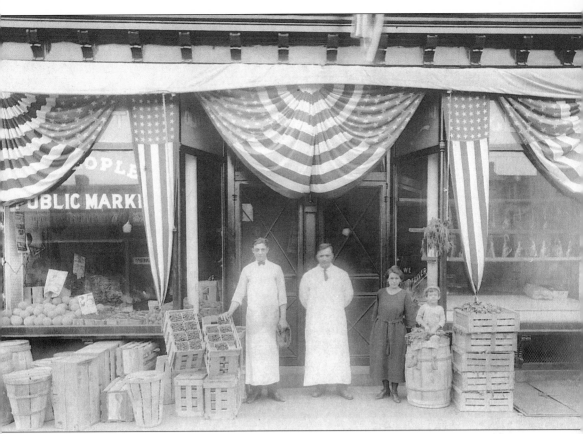

In this photo *c.* 1920, owner John D'Alessio (center) stands in front of the People's Public Market on Richmond Avenue, Port Richmond, on opening day. D'Alessio owned the market for a number of years when Port Richmond was one of the island's most active commercial centers. Markets like the "People's Public Market" were the predecessor of today's chain supermarkets. D'Alessio was also active in many community affairs. (Collection of Antoinette D'Alessio Whittet.)

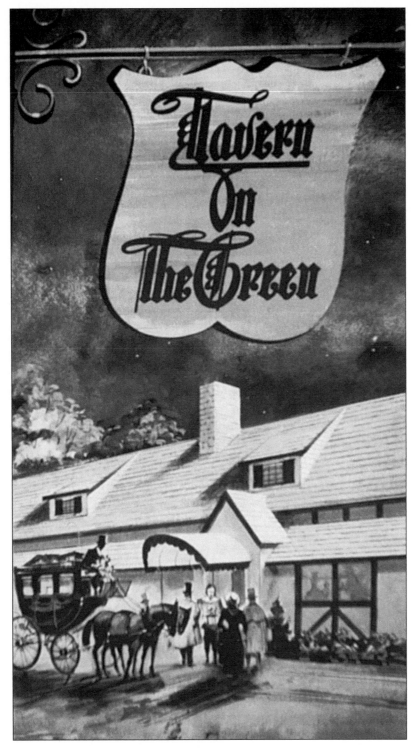

While serving everyday Staten Islanders, the popular Tavern on the Green hosted celebrities and political figures ranging from Rose and Bobby Kennedy to General Alexander Haig, Richard Nixon, Joan Crawford, and Rocky Graziano. (Collection of the Coppotelli family.)

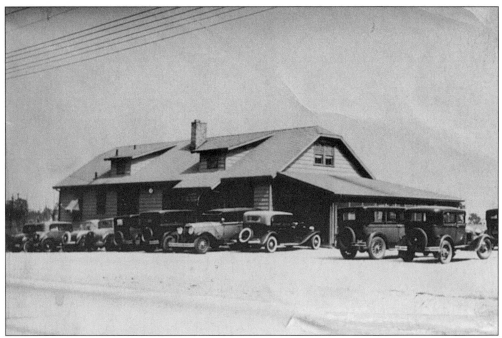

This 1930 photo shows the clubhouse of the Tysen Manor Golf Course, which would go on to become Tavern on the Green, bounded by Hylan Boulevard and Mill Road, New Dorp, and Tysens Lane. (Collection of the Coppotelli family.)

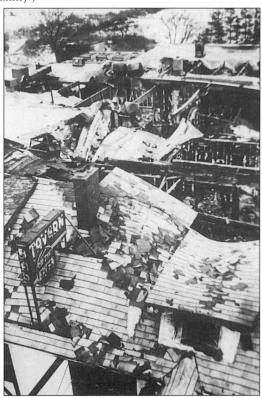

The Tavern on the Green was destroyed by fire in 1977. (Collection of the Coppotelli family.)

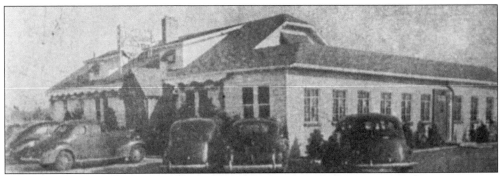

This is the Tavern on the Green in 1938. (Collection of the Coppotelli family.)

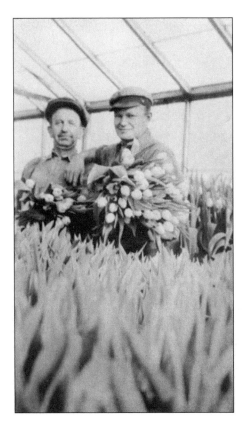

The Mohlenhoff brothers stand in the greenhouse of Mohlenhoff Florists, located on Victory Boulevard in Travis. Initially a garden farm, the business was founded by Henry W.D. Mohlenhoff, a native of Gehrde, Germany. Mohlenhoff was born in 1875 and immigrated to Long Island in 1891. Trained in farming, he worked in this industry until 1921. That year he purchased land in Travis, then called Linoleumville, and began a successful garden market that produced celery, spinach, cauliflower, lettuce, and a variety of flowers. He married Wilhelmine Hugo who was also born in Gehrde, Germany. The couple had 12 children. (Collection of the Mohlenhoff family.)

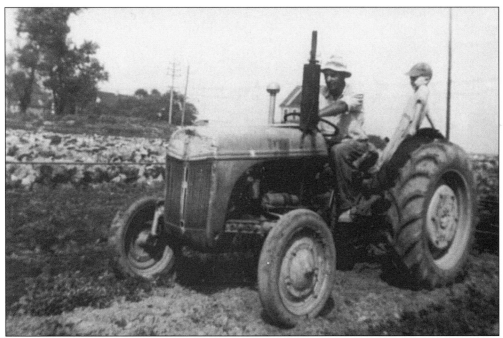

One of the Mohlenhoff kiddies gets a tractor ride. (Collection of the Mohlenhoff family.)

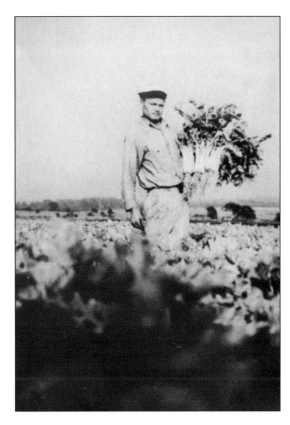

A Mohlenhoff brother holds a stalk of celery. At the turn of the century, produce from Staten Island farms was sent to many other areas of the city. (Collection of the Mohlenhoff family.)

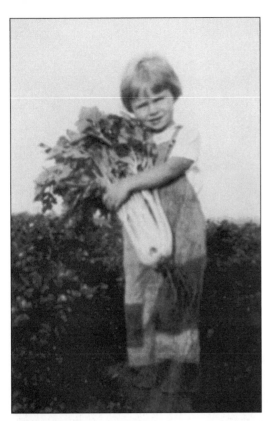

The celery is almost as big as the little girl, Arlene Mohlenhoff, holding it. (Collection of the Mohlenhoff family.)

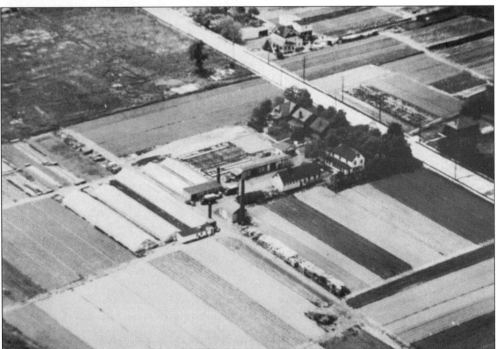

This is an aerial view of Mohlenhoff's Farm and Florist. (Collection of the Mohlenhoff family.)

Six

ISLAND LIFE

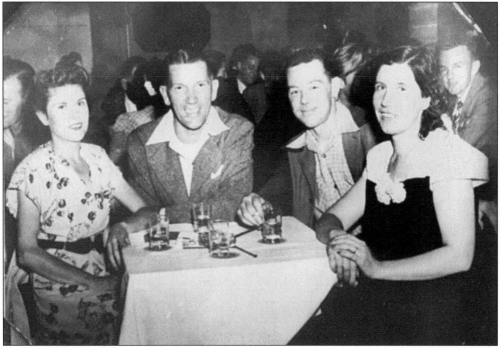

Pictured in this c. 1940s photo are (left to right) Gert and Oscar "Mich" Michaud with Bud and Marguerite Harris at the Miami Club, a popular night spot. Oscar Michaud, who was active in sports both as a player and coach, was one of the first to be inducted in the Staten Island Sports Hall of Fame in 1995. He was supervisor for the Parks Department at Latourette Golf Club for many years. Buddy Harris was a foreman at the U.S. Gypsum Company. Gert and Marguerite were sisters. (Collection of Ted and Noreen Harris.)

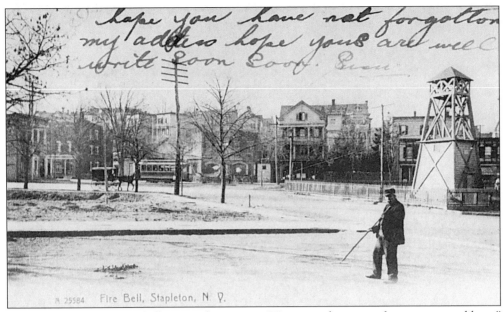

This postcard of the fire bell in Stapleton says, "Hope you have not forgotten my address." (Collection of Randall Gabrielan.)

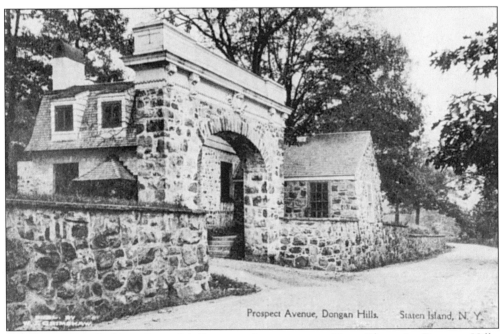

Another postcard shows beautiful Prospect Avenue, now Hagg Place, in Dongan Hills. (Collection of Randall Gabrielan.)

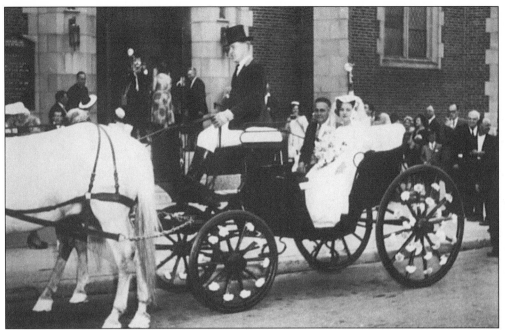

Miss Mary Ann Coppotelli is escorted to Our Lady Queen of Peace Church, New Dorp, by her father, Dominic "Dee" Coppotelli. An alumna of St. Joseph's Hill Academy and Georgian Court College, Mary Ann married Ernest Peter Gregory. The couple honeymooned in California and Hawaii. The beautiful horse and carriage were provided by Franzreb's Clove Lake Stables. (Collection of the Coppotelli family.)

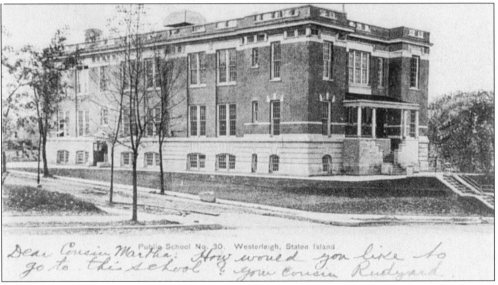

Public School 30 in Westerleigh was built in 1904 on land donated by the National Prohibition Society. The previous location of the school was the former Villa Hotel. Westerleigh has its origins in the prohibition movement and was founded on July 4, 1888. The *Richmond County Gazette* notes in keeping with the theme of abstinence, "Good music, good speakers, good food, and good water are all promised for today." This postcard is dated November 30, 1906. (Collection of Randall Gabrielan.)

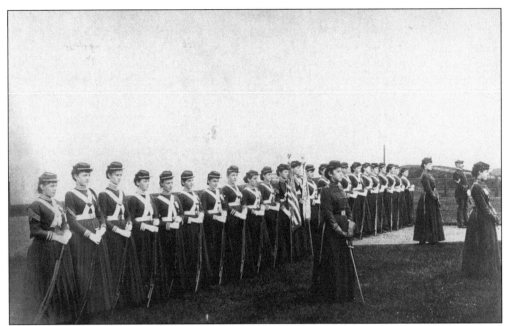

Pictured here are the Young Women Cadets, Auxiliary Group at Fort Wadsworth, June 1889. (Collection of the SIHS.)

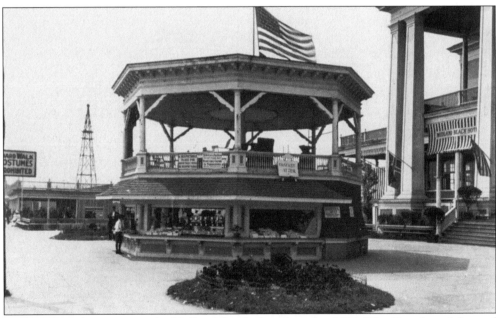

William Grimshaw captures the Midland Beach Grandstand c. 1910. The Grandstand, located next to the imposing Midland Beach Hotel, was the scene of many concerts. Signs announce "Concert at 7 p.m." and warn "To Appear on the Beach in any but Respectable Costume is FORBIDDEN and a Respectable Place for Respectable People. *Be Respectable*." (Collection of the SIHS.)

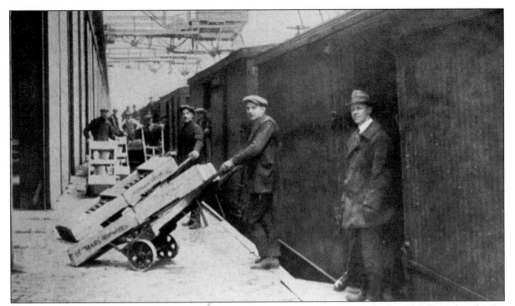

This photo in Borough President Lynch's 1924 Annual Report is labeled "unloading freight for Russia." Three hundred forty-five freight cars loaded with agricultural machinery destined for Russia were delivered to the pier by connection with the Baltimore & Ohio Railroad. The machinery was then loaded onto steamers. (Borough President's Annual Report 1924.) (Courtesy of A. Richard Boera.)

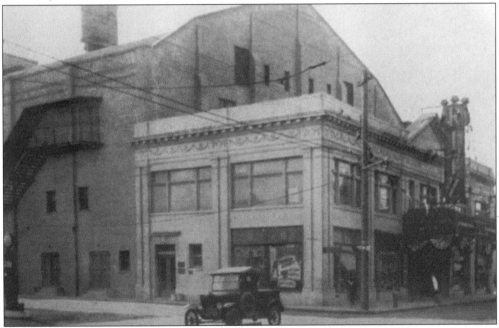

The Ritz Theater, shown here in 1924, was located on Richmond Avenue in Port Richmond. The Borough President Report touts the Ritz Theater as a positive contribution to amusements. The theater has a capacity of 2,500 and after many years of serving as movie theater, it also hosted rock concerts in the 1970s. (Borough President's Report, 1924.) (Courtesy of A. Richard Boera.)

Some dapper Brighton boys sit on the hood of a vintage auto. One of the boys is Tommy Laub, whose family owned Laub's Auto Body Shop on Richmond Terrace. (Collection of Margaret Harris Zack.)

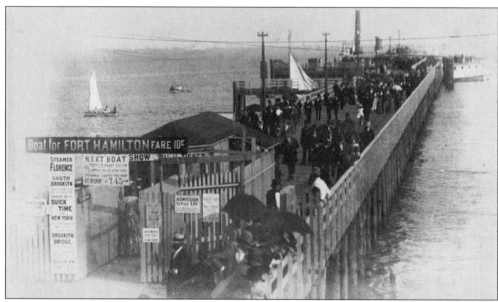

This is the dock at South Beach. In the 1890s steamers made the trip from Manhattan and Brooklyn to take summer visitors to enjoy the beaches and amusements at South Beach. The fare to Fort Hamilton, Brooklyn, was 10¢. One sign announces, "Steamer H.E. Bishop leaves for Jewell's Wharf, Brooklyn, and West 10th Street, New York, at 7:45 p.m." The fare for the steamer Florence was 15¢. It departed approximately every two hours up to 10 p.m. on Sundays and made stops at South Brooklyn, Brooklyn Bridge, and Manhattan. (Collection of the SIHS.)

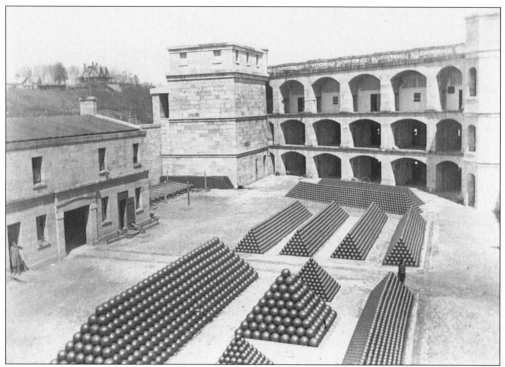

The piling of artillery in Battery Weed, Fort Wadworth, makes an interesting design. In *Secret Places of Staten Island*, author Bruce Kershner notes that Battery Weed, named after Gen. Stephen Weed, had 102 cannons to protect the entrance to the harbor. (Collection of the SIHS.)

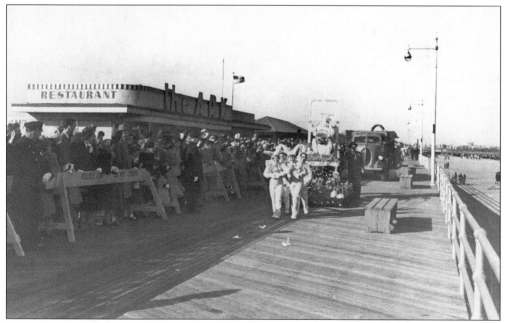

Four bunnies lead the first Easter Parade to celebrate the opening of the boardwalk. The parade was sponsored by the Chamber of Commerce. (The Collection of the SIHS.)

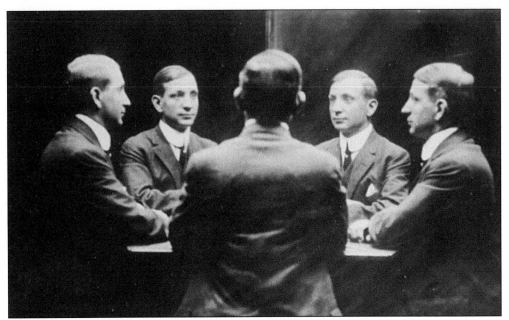

The four "Als" face off in this mirror-image photo of Alvaro Boera. This technique of photography was popular in the twenties and thirties. Boera, known as the "Onion King" because of his Spanish onion import business, went on to become the owner of the popular Old Mill Restaurant in Grasmere. (Collection of A. Richard Boera.)

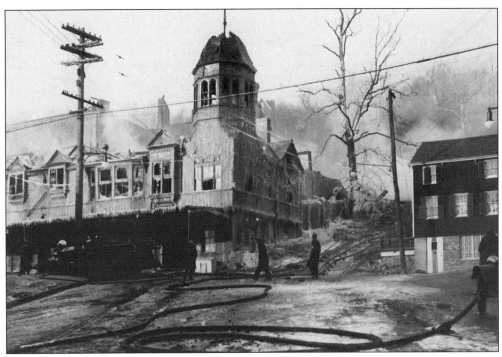

The Bechtel's Brewery Fire occurred on February 3, 1931. (Collection of the SIHS.)

Alice Austen creates a dignified portrait of her grandfather John Haggerty Austen in front of the much-loved family home named "Clear Comfort" in Rosebank. In the background, the Dutchman's Pipe vines are visible, as is a large telescope used to observe vessels as they entered the harbor. (Collection of the SIHS.)

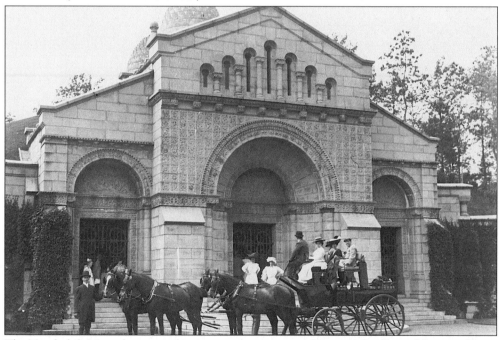

The Vanderbilt Mausoleum stands as a monument to one of Staten Island's wealthiest and most well-known families. The architect was Richard Morris Hunt, and the landscape architect was Frederick Law Olmstead. One of America's greatest fortunes had its origins in the early entrepreneurial activity of family patriarch, Cornelius Vanderbilt. The Vanderbilt family came to Staten Island in the 1600s. Vanderbilt decided to mount a ferry business, which later went on to gain a vast fortune in the burgeoning railroad business. The Vanderbilt Mausoleum is not open for public viewing. (Collection of the SIHS.)

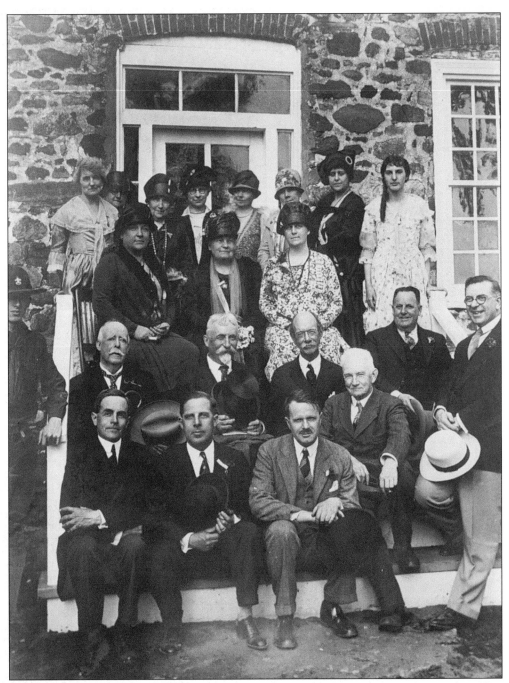

This is a gathering at the Conference (or Billopp) House at the foot of Hylan Boulevard in Tottenville. Built in 1699 as part of the Bentley Manor tract, the Conference House was the site of a meeting during the Revolutionary War in order to reach a peaceful resolution of the differences between England and the colonies. The gentleman with the goatee is Cornelius G. Kolff, who was instrumental in efforts to have the Billopp House taken over by the city. Next to him is Staten Island historian and naturalist William T. Davis. Also pictured are Rev. Henry D. Frost, Chester Cole, Lynn McCraken, Charles W. Leng, and George J. Houtani.

Pictured here in the card that was sent on the occasion of his death in 1950, Cornelius G. Kolff was active in Staten Island civic affairs for more than 50 years. He referred to himself as Staten Island's most obedient servant. He was involved in real estate development, most notably Lighthouse Hill, and lived in the Meissner mansion. A ferry is named in Kolff's honor. (Collection of A. Richard Boera.)

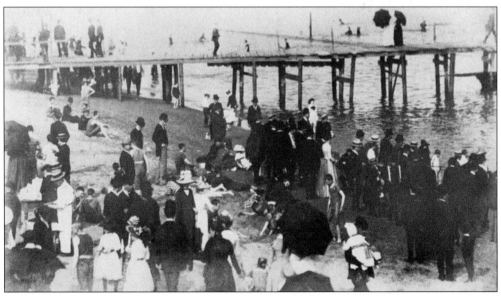

Most bathers appear to be well covered in this South Beach photograph by Isaac Almstaedt in about 1900. (Collection of the SIHS.)

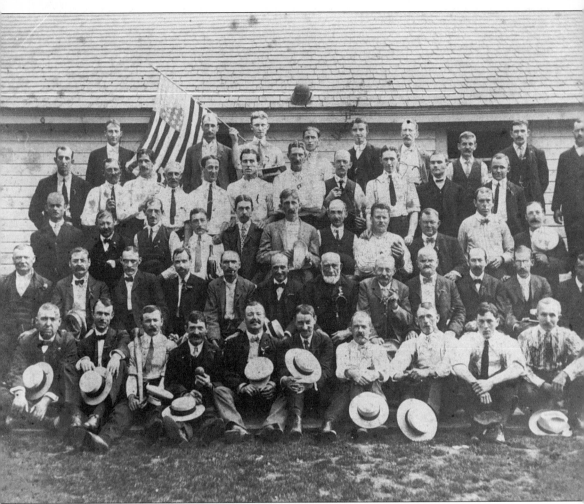

The Amiticia Social Association of Pleasant Plains was photographed in 1907 at Semler's Pavilion in Grant City. The photo was contributed to the SIHS by George Bedell. Pictured left to right are the following: (first row) unidentified man, Frank Bedell, Myron Brown, Josh Hitchcock, Jake Velten, Will Hall, Billy Ostemeyer, Steinmeyer, Will Swade, and Charles Manee; (second row) Steve Slover, Billy Carpenter, Ben Duhurst, Dr. Salter, D.D., Cole Androvette, Dick LaForge, Abe Manee, Bischole, Jim Hogarth, Gus Kenegeeser, Frank Hoag, and Frank Graft. (Collection of the SIHS.)

Pictured here is the Calvary Presbyterian Church in West New Brighton. The postcard is from a photo by William Grimshaw. (Collection of Randall Gabrielan.)

Four friends pose for the camera on Van Buren Street in the 1950s. Bud Harris and Jimmy Harris appear from left to right. (Collection of Margaret Harris Zack.)

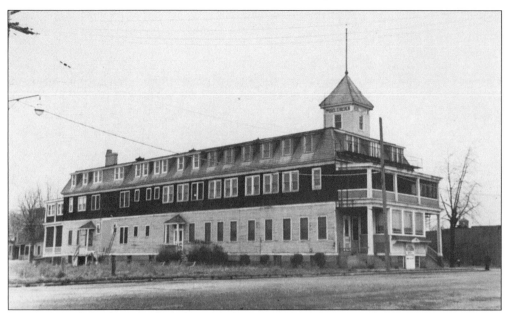

Loring McMillen photographed the Lincoln Hotel, Midland Beach, in December 1953 on a forlorn day during the off-season. McMillen was Borough Historian for 60 years and photographed many Staten Island scenes. (Collection of the SIHS.)

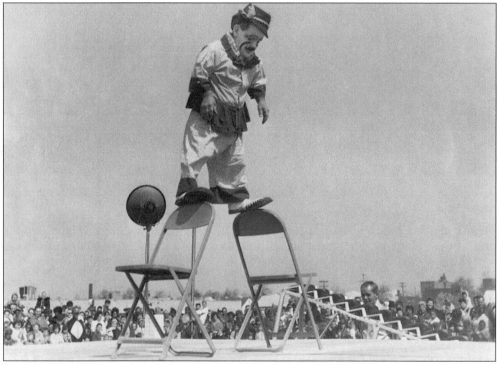

A clown performs at one of the circuses held at Major's in Mariner's Harbor in the 1960s. Major's preceded the Staten Island Mall and offered a different type of shopping to Staten Islanders: single-store, avenue-type shopping like what was found in Port Richmond, New Dorp, and Stapleton. (Courtesy of the Jim Romano Collection.)

Boys dive one after the other from the Tompkinsville pier. The caption should contain a disclaimer, "Please do not attempt this." Kids of all ages have been known to create their own fun, and this seems to be a real daredevil version of the open hydrant that is still a favorite of city kids. (Courtesy of the Jim Romano Collection.)

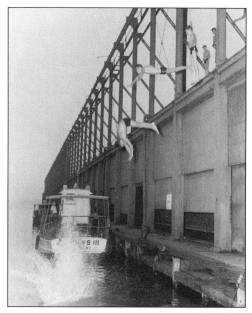

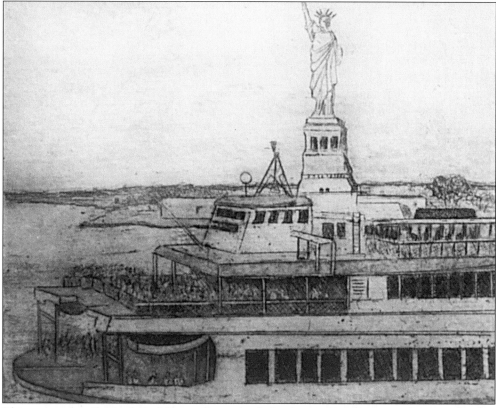

This watercolor, *Passing Miss Liberty*, the work of island artist Fran Romano, depicts a familiar scene. The long-hailed 5¢ ride entitled riders to 25 minutes that included the majestic view of the New York skyline, the Statue of Liberty, Ellis Island, Governor's Island, and a wonderful view of the Verrazano Narrows Bridge. (Collection of Margaret Lundrigan.)

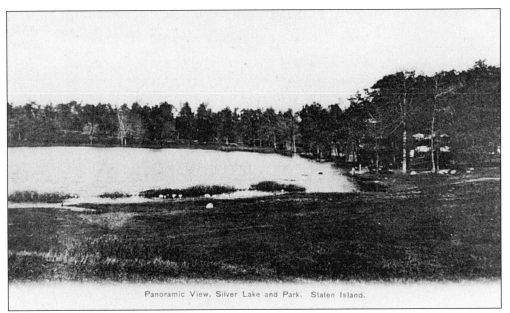

Panoramic View, Silver Lake and Park. Staten Island.

Staten Island's Silver Lake and Park are shown here in a panoramic view. (Collection of Randall Gabrielan.)

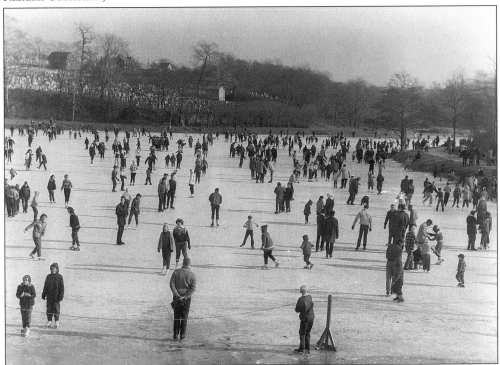

A 1950s scene shows people skating at Martlings Pond. St. Peter's Cemetery is visible in the background. Martlings is one of four ponds that comprise Clove Lakes. As Bruce Kershner notes in his book *Secret Places of Staten Island*, Clove Lakes is home to the "largest living thing"—a tulip tree 107 feet tall and 7 even feet in diameter—at the beginning of the 35-mile-long Greenbelt Trail. (Courtesy of the Jim Romano Collection.)

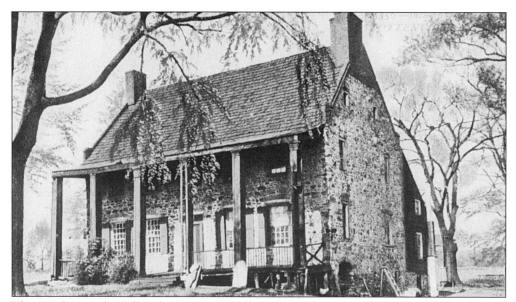

The Conference (or Billopp) House appears here in a color postcard. The beautiful fieldstone manor house was built in 1699 by Christopher Billopp on a 932-acre parcel of land deeded to him by the Crown. During the Revolution the house was owned by Billopp's great-grandson, a Tory colonel also named Christopher Billopp. On September 11, 1776, the Billopp House was the meeting place for peace talks among Benjamin Franklin, John Adams, Edward Rutledge, and Lord Richard Howe. The porch seen in this postcard has been removed. The house is located on a 226-acre park and is open to the public during certain times. (Collection of Randall Gabrielan.)

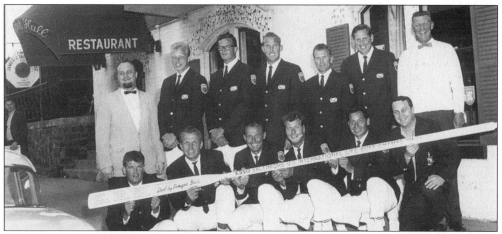

Jack Demyan poses with the 1962 U.S. International Life Boat Champions in front of Demyan's Hofbrau in Stapleton. Demyan, who died in 1999, was known as a restaurateur, an artist whose paintings captured the beauty and spirit of Staten Island sights, and a premier Staten Island "character." His friend, artist John Noble, affectionately called him "Grandpa Moses" and said, "Jack Demyan is a phenomenon of Staten Island. He is an artist in a most unusual and mysterious way and makes New York a richer, more intriguing place." The authors visited Jack briefly after he underwent surgery as a result of diabetes. He said he was looking forward to his latest project: teaching children to draw and paint. Students he helped have established a scholarship fund in his name. (Courtesy of the Jim Romano Collection.)

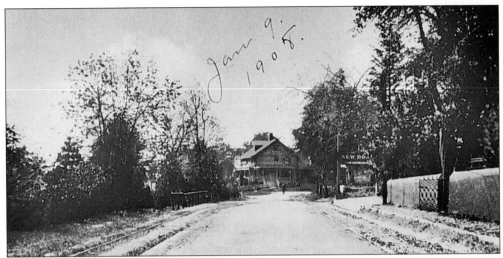

This westward view, showing Richmond Road in New Dorp, portrays a much more rural and less developed Staten Island than most of us remember. Dated January 9, 1908, the card comes from a period between 1905 and 1915 referred to as the "Postcard Era." Local historian Randall Gabrielan notes, "The capture of public imagination by mailable pictorial souvenirs created an international collecting mania, a period of extensive publication and intensive use." (Collection of Randall Gabrielan.)

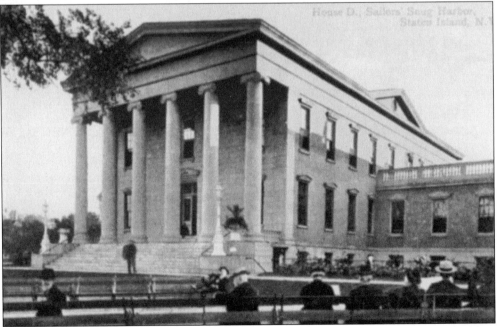

This postcard image shows House D at Sailors' Snug Harbor. The opening of the first building of Sailors' Snug Harbor represented the realization of Robert Randall's generous bequest to "erect . . . an asylum, or marine hospital, to be called Sailors' Snug Harbor for the purpose of maintaining and supporting decrepit and worn-out sailors." At its height, Snug Harbor was home to as many as one thousand retired seamen, and there were more than 50 building on the grounds including dormitories, a church, chapel, hospital, laundry, blacksmith shop, and morgue. (Collection of Randall Gabrielan.)

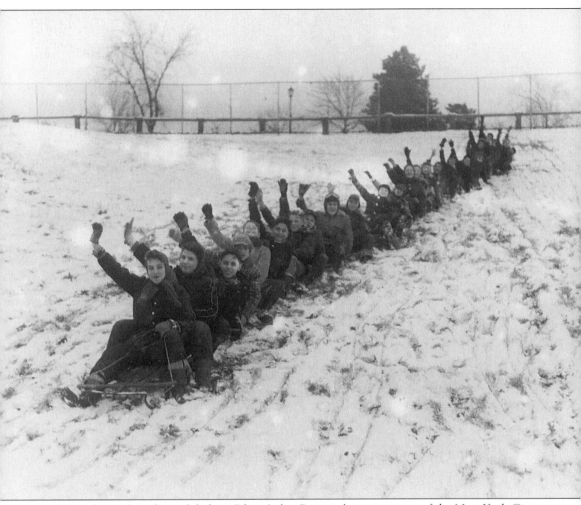

Children form a long line of sleds at Silver Lake. Prior to becoming part of the New York City park system and a reservoir, Silver Lake long provided recreation for Staten Islanders. It was called Fresh Pond up to the 1850s. Silver Lake was home to the Raisch Casino, which had a bandstand and dancing. (Courtesy of the Jim Romano Collection.)

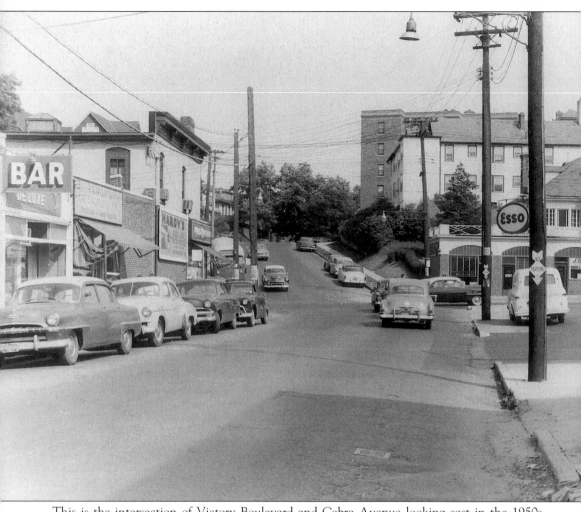

This is the intersection of Victory Boulevard and Cebra Avenue looking east in the 1950s. (Courtesy of the Jim Romano Collection.)

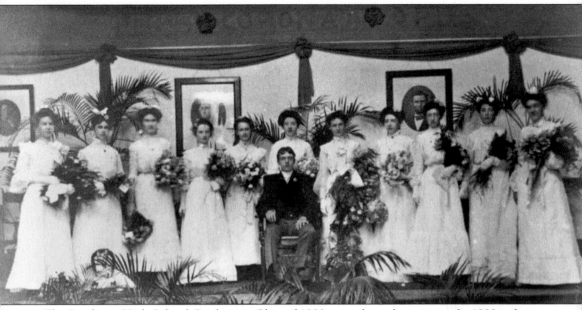

The Stapleton High School Graduating Class of 1902 poses for a class picture. In 1898, a four-year program of study was instituted at the Second Union Free School in Stapleton. The only person identified—and only by last name—is the young man seated in the center, Jacot. (Collection of the SIHS.)

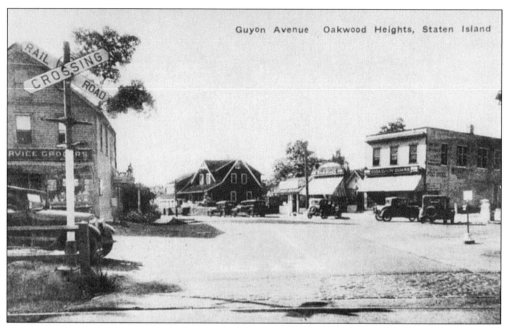

This postcard *c.* 1910 of Guyon Avenue in Oakwood Heights shows a rural view with a railroad crossing and grocery store directly behind the crossing. The post office is in the candy and stationary store at the far right. (Collection of Randall Gabrielan.)

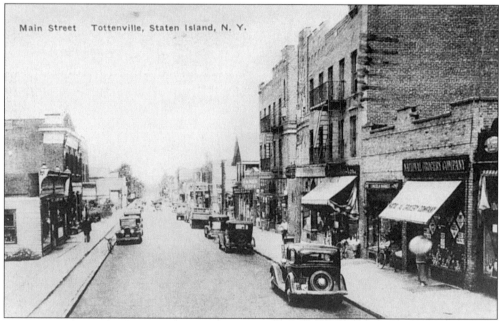

Main Street, Tottenville, appears in this postcard dated July 26, 1937. To the right in the foreground is the National Grocery Company Store, also known as Ralston's. Ralston's was a forerunner of the chain grocery store. The postcard was published by Weitzman's Photo Shop. (Collection of John Rhody.)

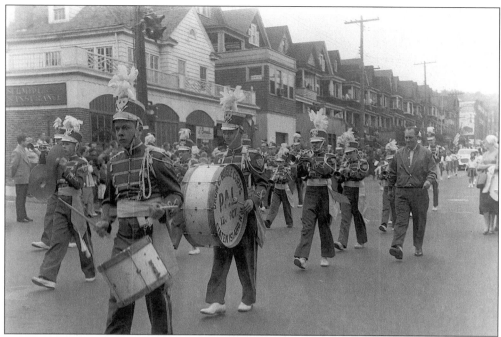

A Police Athletic League Marching Band from the 120th Precinct leads a parade down Victory Boulevard. (Courtesy of the Jim Romano Collection.)

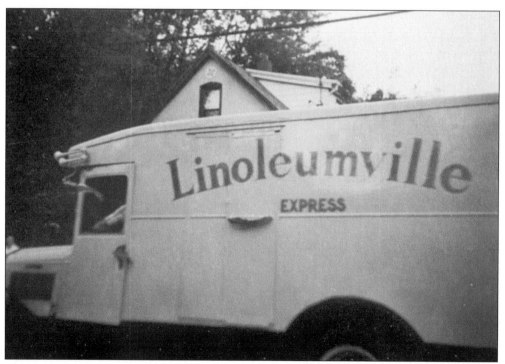

The truck seen here is participating in one of Staten Island's premier events—the annual Travis Fourth of July Parade. Travis was formerly called Linoleumville, after the linoleum factory located there. (Collection of Arleen Braun.)

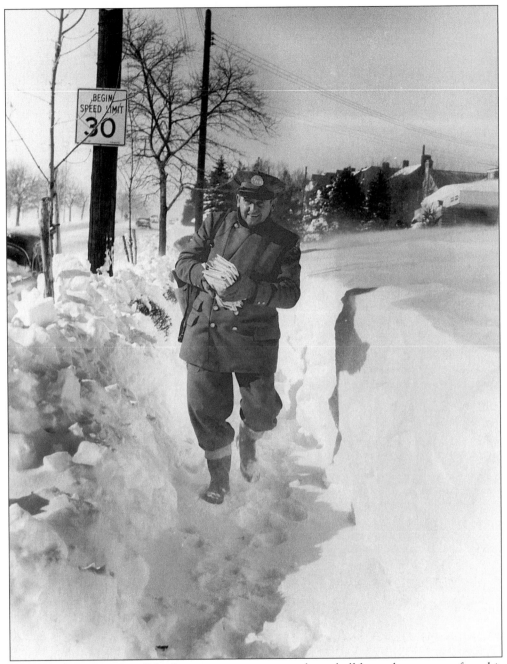

The postal service motto "Neither rain, nor snow, nor sleet, shall keep the postman from his appointed rounds" comes to life in this photo by Jim Romano. (Courtesy of the Jim Romano Collection.)

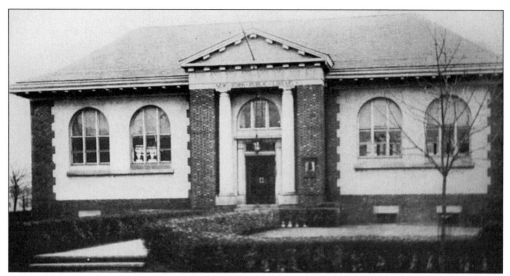

The public library in Tottenville was the first branch of the New York Public Library to open on Staten Island. The Carnegie Foundation had made funds available to communities interested in starting libraries, and Tottenville residents successfully applied for these funds. The Staten Island Resource Manual reports that there had been a public library in Tottenville previously on Johnson Avenue that was formed by the Tottenville Association. The Tottenville Branch was followed by Port Richmond Branch in 1905, and the Stapleton and St. George Branches in 1907. The buildings' architectural designs were of the well-known firm of Carrere and Hastings, which also designed the main branch of the New York Public Library and St. George Borough Hall. (Collection of the Bedell/Pizzo Funeral Home.)

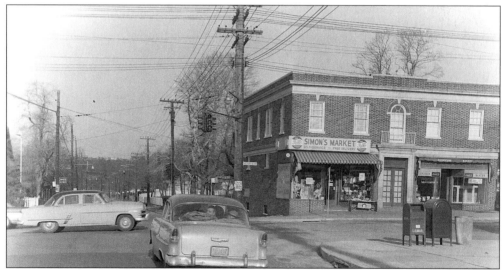

A 1950s scene of Clove Road and Victory Boulevard in Sunnyside shows Simon's Market and the Sunnyside Bakery and Luncheonette. These building have been demolished. To the left, the Clover Club, a bar and grill, is barely visible. Not visible but behind these stores was the home of Staten Island historian and author Dorothy Valentine Smith. Smith owned two homes adjacent to each other. They became the subject of controversy when, after her death, an heir wished to sell the homes many preservationists considered of historic value. (Courtesy of the Jim Romano Collection.)

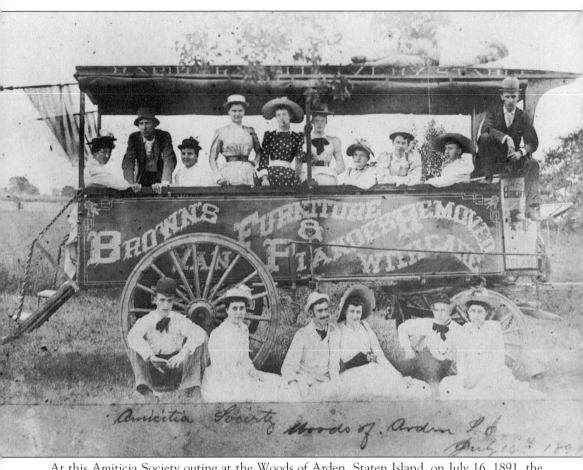

At this Amiticia Society outing at the Woods of Arden, Staten Island, on July 16, 1891, the group stands in front of Brown's Van, which advertises "Furniture and Pianos Removed with Care." (Collection of the SIHS.)

Dominic "Dee" and Marion Coppotelli were married in 1938. The couple owned the Tavern on the Green Restaurant, purchased with Dee's father, Ambrose, in 1948 and sold in 1974. Active in the Democratic Party, Dee was the island campaign manager for both Governors Hugh Carey and Mario Cuomo. He was a commissioner of the New York State Racing and Wagering Board. He was also a member of the board of trustees of Staten Island University Hospital for 18 years. Coppotelli was the designer and builder of Bowling on the Green. His wife, the former Marion Kennedy, worked with him throughout their ownership of the restaurant and bowling alley. (Collection of the Coppotelli family.)

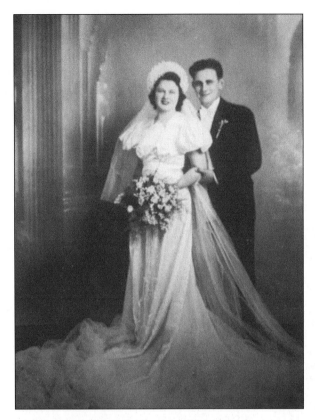

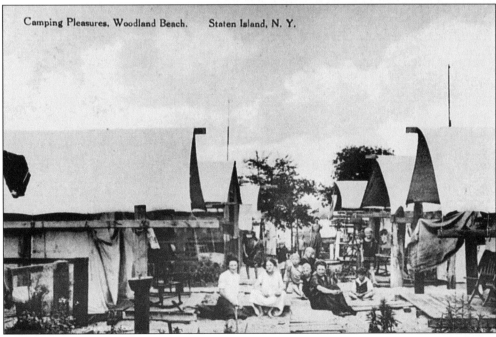

Camping Pleasures, Woodland Beach. Staten Island, N. Y.

This postcard is entitled "Camping Pleasures, Woodland Beach." (Collection of Randall Gabrielan.)

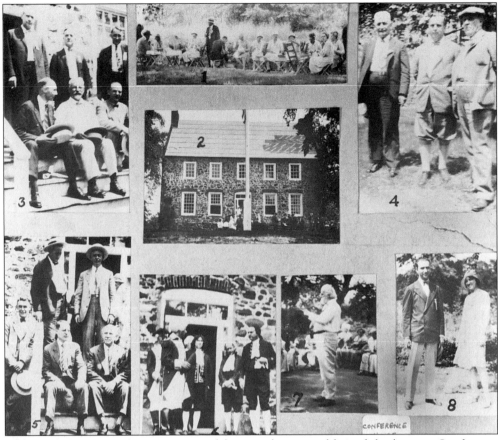

A montage of photos depicts events celebrating the stewardship of the historic Conference House in 1929 by the Conference House Association from the City of New York. (Collection of the SIHS.)

New Dorp Lighthouse operated from 1865 to 1964. It is noted for vernacular architecture and has been restored as a private home. (Collection of Randall Gabrielan.)

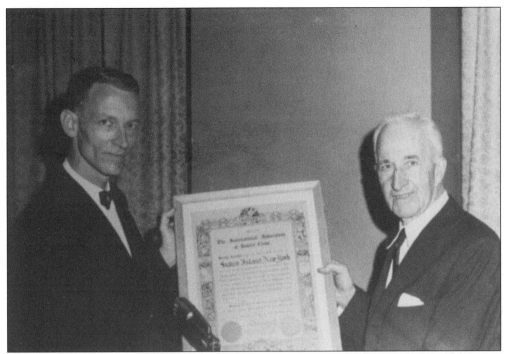

Dick Boera (left), president of the Staten Island Rotary Club, presents an award. (Collection of A. Richard Boera.)

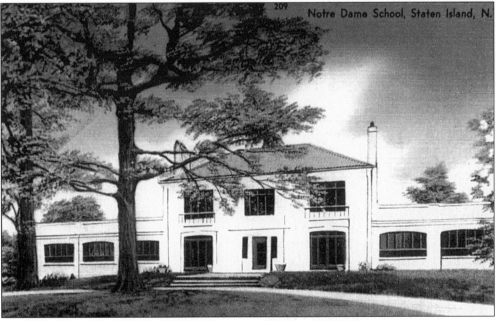

Notre Dame Academy was founded in 1903 by the Sisters of the Congregation of Notre Dame. The school is on Howard Avenue near Louis Street and began with an enrollment of 12 students. A few years later the John Scott estate on Howard Avenue was purchased. In 1925, the Dreyfus Estate became the high school, and in 1959 a new high school was erected. (Collection of Randall Gabrielan.)

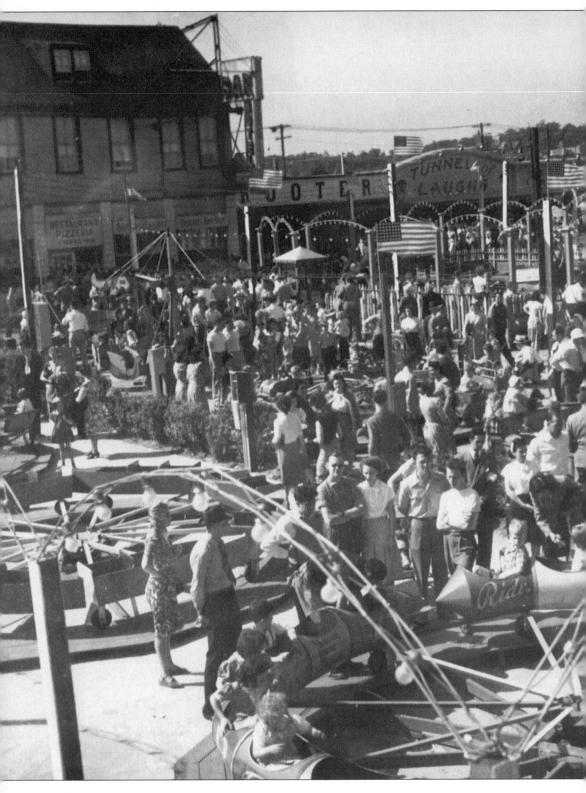

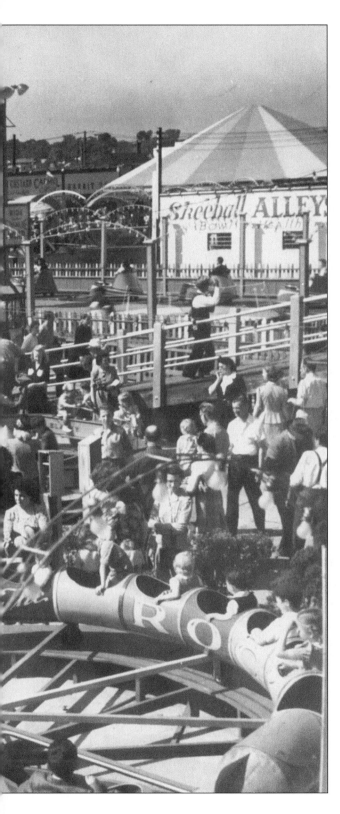

This early 1960s photograph shows South Beach's Kiddie Park on a typical day. (Collection of the SIHS.)

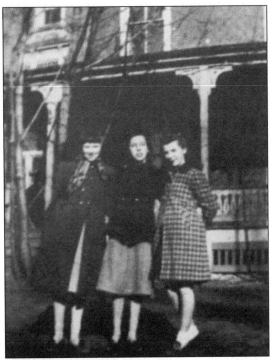

Three young women pose in front of the two-story house that was the original St. Paul's School. (Collection of Margaret Harris Zack.)

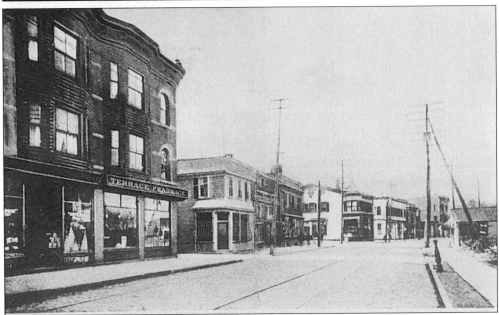

An early postcard of Richmond Terrace in Mariners Harbor shows the Terrace Pharmacy in the foreground. One of the many places that have undergone name changes, Richmond Terrace was at one time called Shore Road. Forest Avenue had been Cherry Lane and Victory Boulevard was the Richmond Turnpike. Richmond Road was Kings Highway. In a map dated 1896, historians Charles W. Leng and William T. Davis share some of the colorful old names such as Skunk's Misery, Rotten Meadows, Poverty Lane, Tipperary Corners, Peanutville, and Little Africa. (Collection of Randall Gabrielan.)

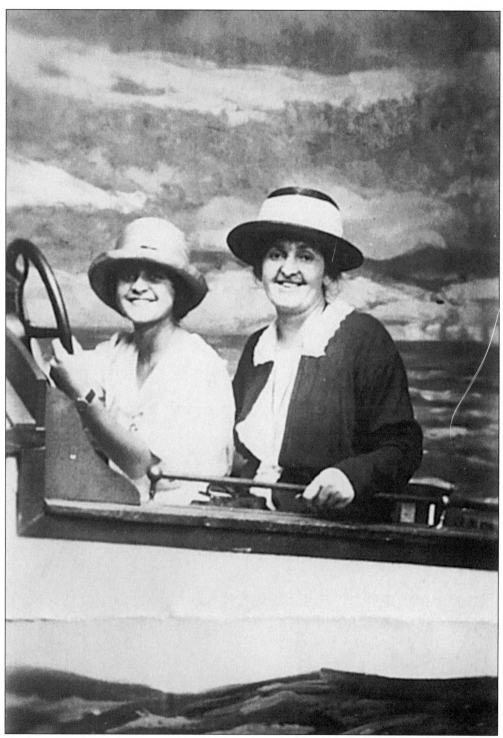

Anchors aweigh! Clara Manz and her mother, Paula, take a trial run in a photographer's studio in the summer of 1920. Miraculously, the hats aren't disturbed by the breeze. (Collection of A. Richard Boera.)

Monnsignor Farrell was the pastor of St. Paul's Church in New Brighton. Monsignor Farrell High School was named for the revered priest.

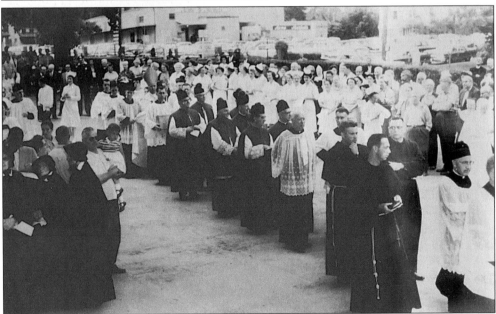

This procession was in honor of the opening of the Cardinal Spellman Pavilion addition to St. Vincent's Hospital. Bishop John J. Maguire presided at the laying of the cornerstone on June 10, 1960. The $2.5 million addition provided beds for another 100 patients, increasing the hospital's capacity to 350, and became the site of the hospital's school of nursing. The new wing also housed 6 new operating rooms and a 12-bed recovery room.

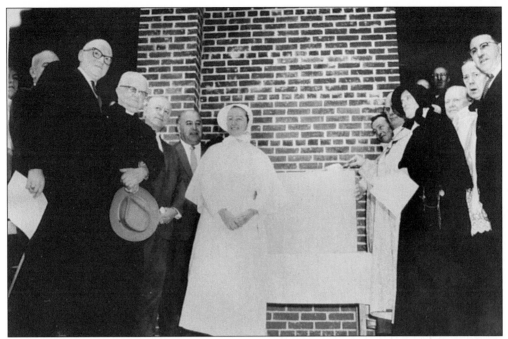

At the ceremony are, from left to right, Rabbi Benjamin Wyansky of Temple Emanu-El. B.P; Rev. Frederic Sutter, pastor of Trinity Lutheran Church; Borough President Albert Maniscalco; Sister Edward Mary, administrator, in white habit; and Mother Mary, president of the hospital board of managers in black habit. Addresses were given by Albert V. Maniscalco, borough president, Dr. Amoury, and Dr. H.C. Nicholson. Greetings were also extended by Rev. Frederic Sutter and Rabbi Benjamin Wyansky. Maniscalco noted the importance of the new wing, saying it was "extremely important as there is no general city hospital in our borough."

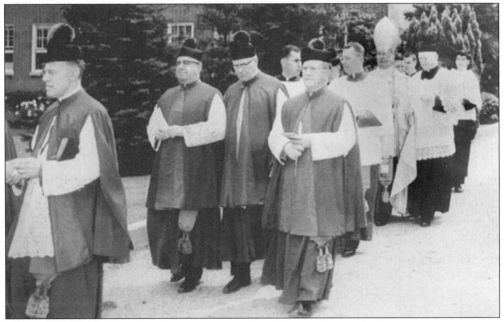

Bishop Maguire, with staff and mitre, is escorted to the cornerstone-laying ceremony.

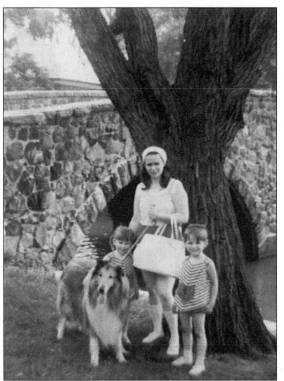

Rita "Merrie" Lindsey with her daughters Krisia and Lisa and a beautiful collie pose in front of one of the many lovely stone arch bridges in Clove Lakes Park. Merrie Lindsey has worked for number of years at the Health Insurance Program (HIP) located on Clove Road. A survivor of breast cancer, Merrie has been active in many cancer support groups and has been in a video on the topic of breast cancer. Rita (Krisia) is an accountant and lives on Staten Island. Lisa is an nurse with two children and lives on Staten Island. Her son Tom was not yet born when the photo was taken. (Collection of Rita Merrie Lindsey.)

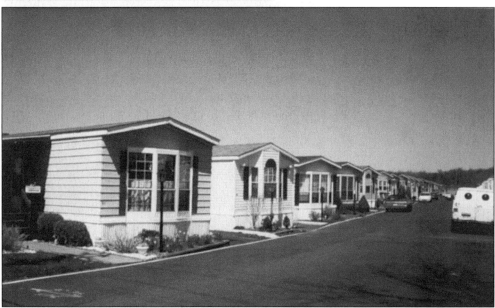

The Goethals Garden Homes Community is the only mobile home community in New York City. Brothers Fred and Frank DeDomenico established the 9-acre community in 1969 because, at the time, zoning allowed for the building of mobile home units on land zoned for manufacturing. The Goethals Home Community, which has maintained high standards, represents an attractive and affordable residential alternative. The community contains 128 homes. (Photo by Margaret Lundrigan.)

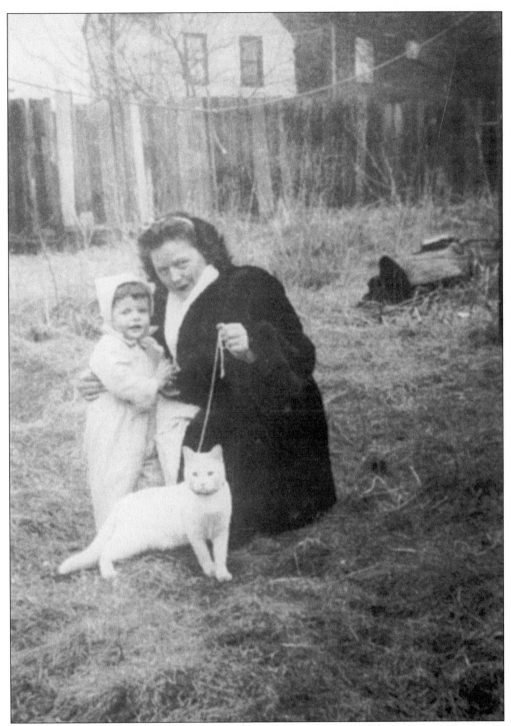

May Harris Malsen poses for the camera with son Jackie and a regal feline. May was known for her elegant clothes, pretty face, sharp wit, and love of felines. She was the daughter of Andrew and Mary Harris, longtime residents of New Brighton who had eight children. (Collection of Margaret Harris Zack.)

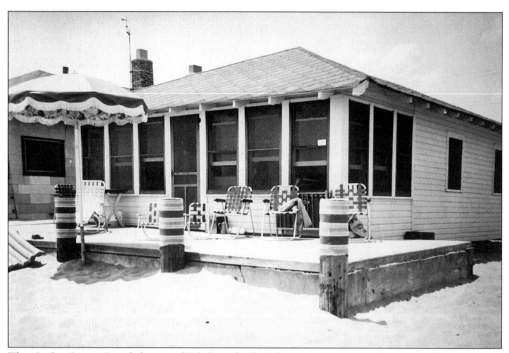

The Cedar Grove Beach home of Edith and Al Holtermann was simple but well located. The private beach, which developed in the 1920s, has long been a select beach resort of Staten Island. (Collection of Edith and Al Holtermann.)

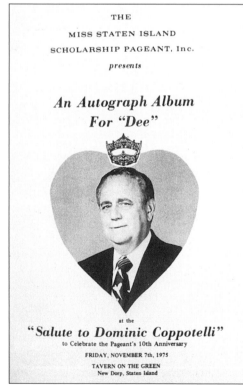

On November 7, 1975, Dominic "Dee" Coppotelli was honored at a dinner at the Tavern on the Green for the role he played in developing the "Miss Staten Island Scholarship Pageant." The brochure from the dinner is entitled "An Autograph Album for Dee." Coppotelli was active in many Staten Island affairs. Coppotelli, along with his longtime friend, Joe Sciacco, cooked for runners in the annual New York Marathon, with pasta and sauce provided by the Ronzoni Company. He was honored for his many accomplishments by a Legislative Resolution introduced by Senator John Marchi. (Collection of the Coppotelli family.)

Kari Pedersen, Miss Staten Island in 1967, went on to win the Miss New York title the same year. (Collection of the Coppotelli family.)

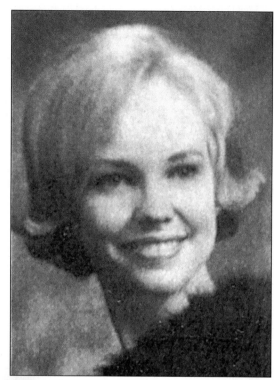

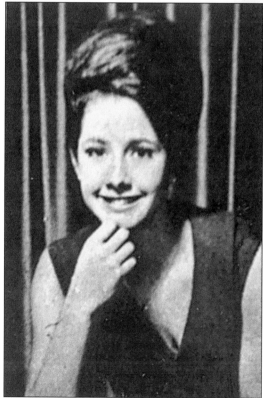

Lynne Memoly took the title of Miss Staten Island in 1967. The daughter of George and Vivian Memoly, owners of Memoly Dodge, Lynne is an entrepreneurial spirit who has been a clothing and accessories designer and an art-gallery owner, among her other accomplishments. (Collection of the Coppotelli family.)

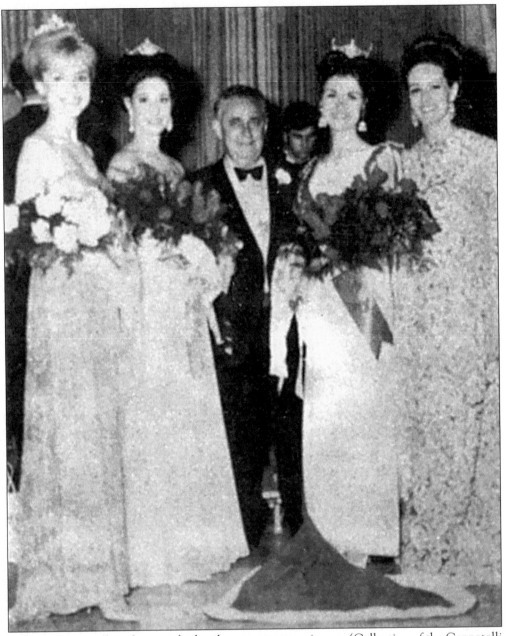

Dominic Coppotelli is photographed with some pageant winners. (Collection of the Coppotelli family.)

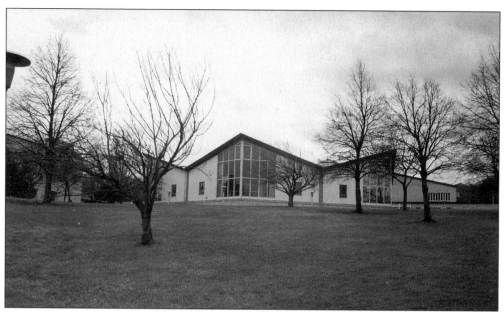

The completion in 1964 of the college campus, which was previously called Staten Island Community College, on the 40-acre campus overlooking the Staten Island Expressway was a long-awaited event. The project cost more than $9 million and represented a leap forward for public education on Staten Island. The college had previously held classes in a campus of office buildings in St. George. In 1976, Staten Island Community College, then a junior college, joined with Richmond College in St. George to form the College of Staten Island. The cafeteria of the College of Staten Island is shown above. (Photo by Tova Navarra.)

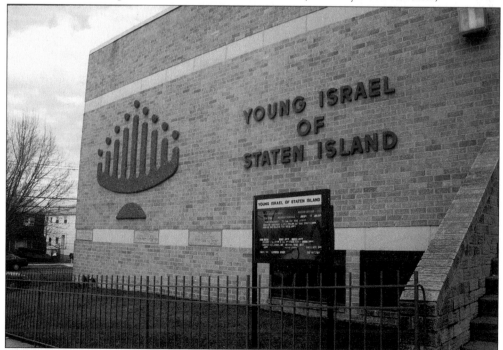

This is the Young Israel Synagogue. (Photo by Tova Navarra.)

The Woods of Arden House was the home of landscape architect Frederick law Olmstead from 1848 to 1860. Called the father of American landscape architecture, Holmes is the designer of New York's Central Park, Brooklyn's Prospect Park, Boston's Franklin Park, and Philadelphia's Fairmont Park. Located on Hylan Boulevard, the home was originally the Akerly Farm. The first section was built in 1690. The house is now the home of Carleton Beil, one of Staten Island foremost naturalists. (Collection of the Beil family.)

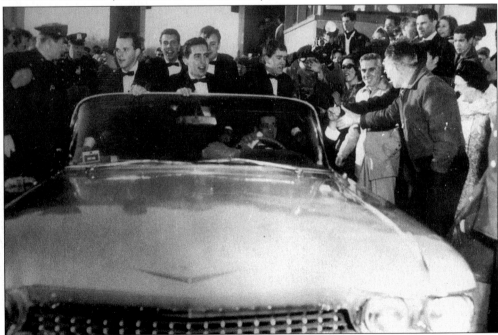

Young men in a convertible cross the Verrazano on opening day, November 21, 1964. (Collection of George Scarpelli.)

In this postcard of Midland Beach taken by A. Loeffler of Tompkinsville, there appear to be more people on the boardwalk than the beach. Midland Beach had several hotels, an amusement park, pier, and boardwalk, and was accessible by train and steamer. This card, dated August 12, 1905, is particularly noteworthy because of its message: "Hope you are enjoying yourself as much as I am. Best regards to all, John D. Hincliffe." The Hincliffe family had purchased Midland Beach Amusement from the Midland Railroad Company. (Collection of John Rhody.)

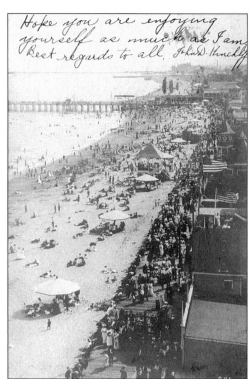

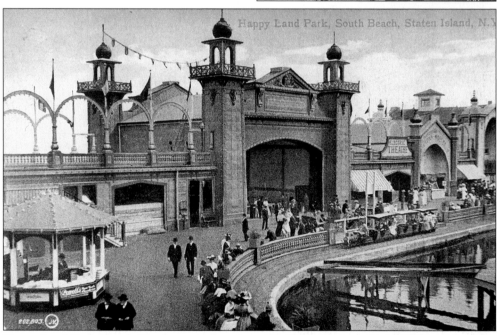

Happy Land Park, South Beach, opened on June 30, 1906, to a crowd of 30,000 visitors. The beautiful park with a theater, amusement park, and several hotels was one of the premier amusement parks of its era, rivaling Steeplechase and Luna Park. The park failed to prosper because it was dependent on tourists for revenues. Fires devastated the area in 1917 and 1929. (Collection of John Rhody.)

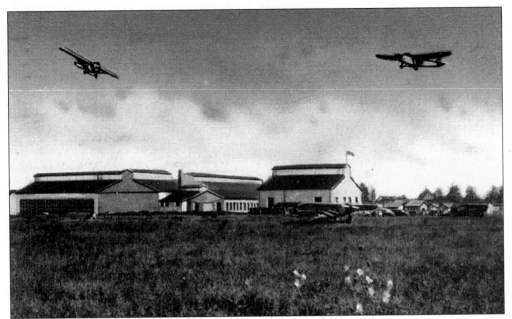

Miller Aviation Field in New Dorp was located at the foot of New Dorp Lane on land that had been the William Vanderbilt farm. Much of the wreckage of a tragic 1960 air crash of a United Airlines DC 8 and a TWA Constellation over Staten Island landed in Miller Field. There were 134 fatalities in that crash. (Collection of John Rhody.)

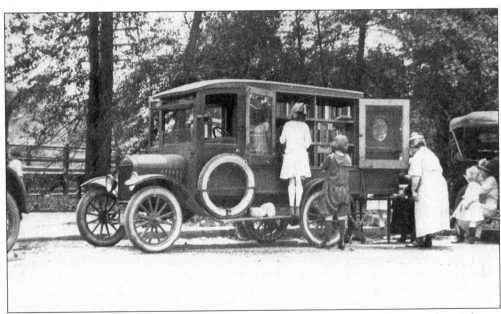

In this postcard two young ladies step up to inspect the selection at the Traveling Library. (Collection of John Rhody.)

The Franzreb family appears here at the annual St. Patrick's Day parade on Forest Avenue. Like the Travis Fourth of July parade, the St. Patrick's Day parade has become a staple in Staten Island social life. Organized by Staten Island's Ancient Order of Hibernians, the parade includes schoolchildren, police and fire department members, and a variety of other organizations. In this photo, mother Adele Franzreb is seated in the center with her sons, John III and Bill, and her grandchildren, Wendy and John. John III's wife, Judith, is also pictured. (Collection of the Franzreb family.)

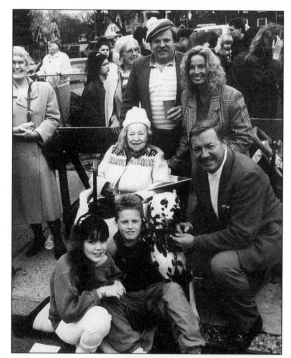

Carleton Beil, one of Staten Island's leading naturalists, is honored at a surprise birthday party. Employed by the Museum of Natural History, Beil was in charge of the museum's traveling collection. From a very early age, he has been fascinated by natural history, particularly Staten Island's, and has given much time to its study and to sharing his knowledge with others. Beil has passed this avocation along to his children: Carlotta Defillo, seated next to her father, is a librarian in the photographic collection of the SIHS, and Eloise was a curator at the Staten Island Institute of Arts and Science. Felicity has been involved in many teaching roles at Richmondtown Restoration. (Collection of the Beil family.)

BIBLIOGRAPHY

Bayles, Richard M., ed., *History of Richmond County (Staten Island), New York, From Its Discovery to the Present Time*, L.E. Preston & Co., NY, 1887.

Brown, David J., *Bridges*, Macmillan Publishing Company, NY, 1993.

Campbell, Amy, comp., *Statistical Guide, Staten Island, New York, 1990–1991*, Staten Island Chamber of Commerce, NY, 1990.

Clute, J.J., *Annals of Staten Island, From Its Discovery to the Present Time*, Heart of the Lakes Publishing, Interlaken, NY, 1986.

Dubois, Theodora, and Smith, Dorothy Valentine, *Staten Island Patroons*, The Staten Island Historical Society, NY, 1961.

Holden, Edna. *Staten Island: A Resource Manual for School and Community*, Board of Education of the City of New York, 1964.

Jackson, Kenneth T., ed., *The Encyclopedia of New York City*, Yale University Press, New Haven, CT, and The New York Historical Society, 1995.

Leng, Charles W., and Davis, William T., *Staten Island and Its People: A History, 1609–1929*, Lewis Historical Publishing, NY, 1930.

Morris, Ira K., *Memorial History of Staten Island*, published by author, West New Brighton, Staten Island, NY, *c.* 1900.

Novotny, Ann, *Alice's World: The Life and Photography of an American Original, Alice Austen, 1866–1952*, The Chatham Press, Old Greenwich, CT, 1976.

Sachs, Charles L., *Made on Staten Island: Agriculture, Industry, and Suburban Living in the City*, Staten Island Historical Society, NY, 1988.

Shepherd, Barnett, *Sailors' Snug Harbor, 1801–1976*, Snug Harbor Cultural Center, NY, 1979.

Steinmeyer, Henry G., *Staten Island, 1524–1898*, The Staten Island Historical Society, Richmondtown, Staten Island, NY, 1987.

Swasy, Alecia, *Soap Opera: The Inside Story of Procter & Gamble*, Times Books, Random House, NY, 1993.

Szekely, George, and Gabay, Dianna, *A Study of a Community: Staten Island Architecture and Environment*, The Staten Island Continuum of Education, Inc., NY, 1980.

Urban, Erin, *John A. Noble: The Rowboat Drawings*, The John A. Noble Collection and South Street Seaport Museum, NY, 1988.

Zavin, Shirley, *Staten Island: An Architectural History*, Staten Island Institute of Arts and Sciences, NY, 1979.